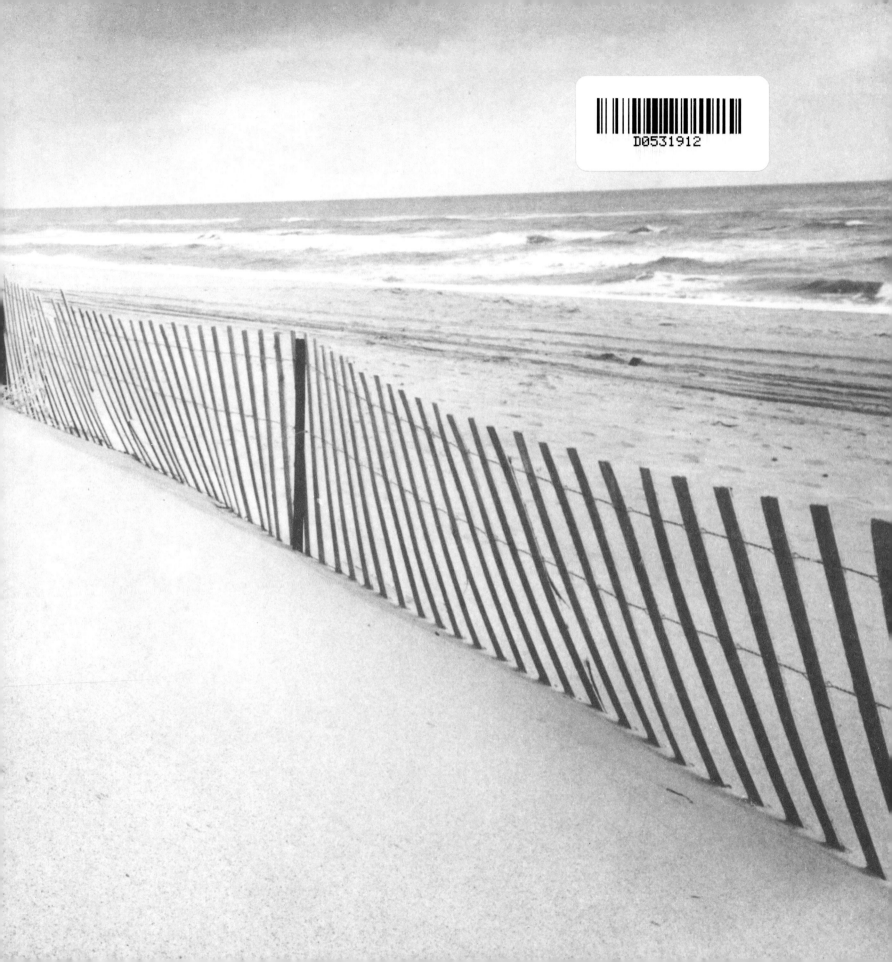

Yellowpup

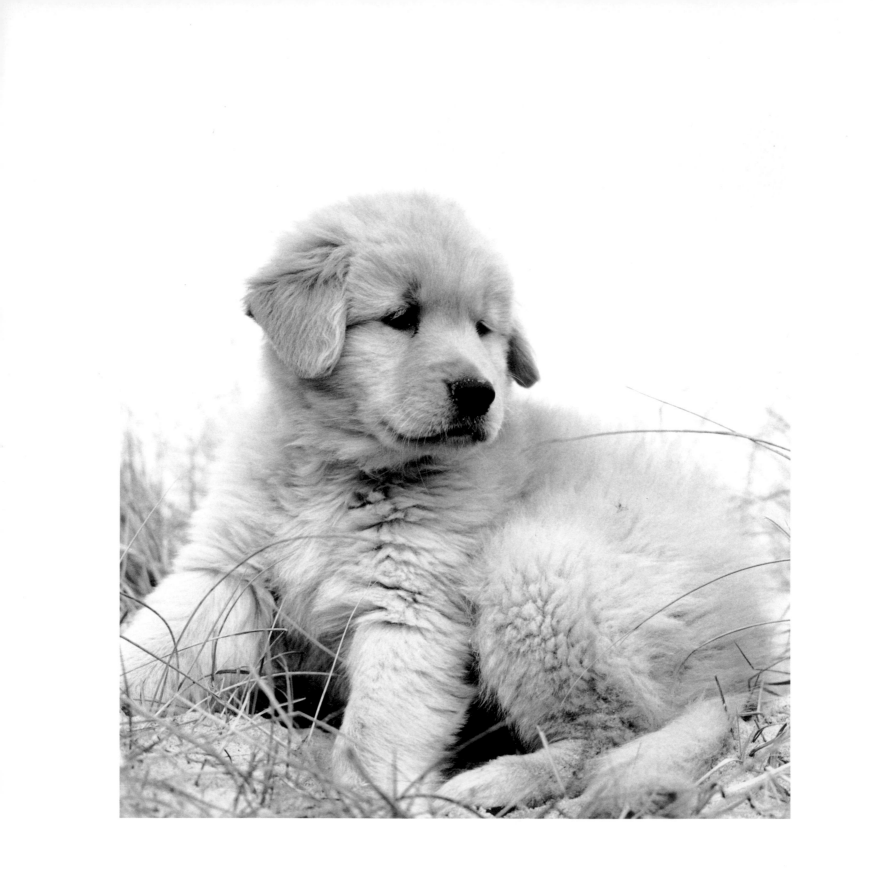

Yellowpup

Debra Marlin

A BULFINCH PRESS BOOK
LITTLE, BROWN AND COMPANY
Boston New York London

FIRST EDITION

LIBRARY OF CONGRESS CATALOGING-IN-PUBLICATION DATA

Marlin, Debra.
 Yellowpup / Debra Marlin.
 p. cm.
 "A Bulfinch Press book."
 ISBN 0-8212-2564-2
 1. Photography of dogs. 2. Golden retriever — Pictorial works.
 3. Golden retriever — Anecdotes. I. Title.
 TR729. D6M37 1999 99-18351
 636.752'7— dc21

BOOK DESIGN BY JEANNE ABBOUD AND DEBRA MARLIN

Bulfinch Press is an imprint and trademark of Little, Brown and Company (Inc.)

PRINTED IN ITALY

If you would like information on ordering limited edition prints or lithographs,
please contact Yellowdog Gallery, 39 Broad Street, Charleston, South Carolina 29401.

Frontispiece: *The Shearling*

Dedicated to Sandra Wand, Barbara Ivacek, and
Sandra Swales, my three fairy godmothers, whose
metaphysical wisdom and patience has guided me home

the heart was quiet

the River flowed

the beat returned

River: Return of the Flow

◆

I T WAS A BALMY JUNE TWILIGHT on Martha's Vineyard, much like the evening a year ago when this puppy fascination began for me. As I made my way in my Jeep along the sandy beach roads and through the streets of Edgartown, I wondered what the evening would hold.

My love story to my Golden Retriever, Sonny, had been in bookstores for a few weeks. *Yellowdog* had heralded a time of unimagined change in my life, and I was curious as to what my next odyssey would be. I had come to this island thirteen years ago as a jewelry designer and soon had a small shop on the water. I watched my business grow nationally, only to then let it go and return to my first love, photography. Jewelry making was now my past, the shops were my past, and now it seemed *Yellowdog* was my past. The book that I had at first published myself was somebody else's baby now, and I was ready for the next step. I wondered.

A friend had told me that an author of books dealing with intuition, sixth sense, and psychic knowing was speaking in Edgartown's Old Whaling Church. Since I was always receptive to the information received along these channels, I decided to attend, figuring that my new path might be revealed. What lay ahead for me now? Would I be besieged by offers from fine-art galleries to hang my images? Would the trendiest fashion magazines plead for me to photograph their supermodels in the quiet Vineyard light? My imagination danced across a field of exciting possibilities as I parked and entered the hall of the great old structure.

The author spoke for a while on the validation of extrasensory perception by the scientific community. The audience listened intently. We all bobbed our heads at those points she made that struck us as familiar. About halfway through, the instructor counted us down to a relaxed meditative state. She painted a verbal picture of a beautiful, enchanted glade set deep in the forest. Using visualization, we were to traverse the wooded path along the stream until we came to a point at which we wished to stop. It was there that we would find peaceful sanctuary for an overcrowded mind. There our spirit guide would appear to us, and as we elucidated our deepest, most heartfelt longings, we would be shown our path.

I had mixed feelings. I was in a calm, restful trance, but there was another side of me that wasn't letting go. I was expecting to see glimpses in my guided imagery of the Concorde whisking me off to foreign ports to photograph the signings of the newest peace accords. Or perhaps accepting the award for my winning documentary at Cannes. I forced myself to try to receive the peace the speaker intended for us. Suddenly, when I had reached the point of my greatest relaxation, my new path appeared before me.

A bit mystified at first at the large dark object with two even darker orifices on either side, I relaxed even further and the image became clearer. The object was Sonny's big black nose. Behind it danced his laughing golden eyes set as I'll always remember them in his large, soft, square head. In his lovely gaze I felt safe and found compassion. So many times I had wanted to summon him to my dreams but would stop short in my greater wish for him to run free in his heavens without looking behind for me. I had waited so long to be visited by him in his own time, but he hadn't come. And then suddenly there he was. I could feel the love I'd always known for him, which was surely the greatest love I had ever been capable of.

My closed eyes filled with tears. In my heart I greeted him, while I wondered if any-

one else in the room had been visited by a loved one. I was incredulous. Not only was this a visit from Sonny, but it was also an indicator of my path.

"But, Sonny, I've already done this *Yellowdog* thing," I said to him. His smiling face beamed even brighter. "Okay," I said, resigning myself. "I guess I'll just go with the flow."

He left as gently as he'd appeared. He left me knowing my path but with the confusion attendant to answers that come in such a mysterious fashion. He left and the stars listened patiently to my boastful remonstrances to those who so innocently referred to me as a dog photographer. "No," I corrected so many times that summer. "No. I'm not working on another dog book."

Meanwhile, my other projects were not developing in the swift fashion I had come to expect when I was on the right track with something. Finally, in a moment of surrender on New Year's Eve, I told my agent that my breeder was having three litters of Goldens in a few weeks and I joked with her that perhaps a puppy book was in order.

The idea took hold. Happy New Year. It took only a few days for the agent to call back to say that the editor loved the idea. "*Yellowpup*," she stated, "is your new book." I don't know whether it was me, the agent, or the editor who first referred to this project as *Yellowpup*, but that seems to have always been its name. I was back on my path.

He came to me in midwinter of 1998. An unexpected child-dog. Never had I been so sure I'd taken leave of my senses as when I agreed to acquire a fourth Golden Retriever. I named him River. During that uncertain time in my life, I'd been repeating to myself the words "go with the flow," and so I did. I had a contract for a puppy Golden Retriever book, but no puppy. I knew I needed to have a puppy around constantly to do my best on the book, but how realistic was that if I couldn't even afford my rent?

Then one Sunday the breeder called to say that if I could make up my mind within an

hour, she would lower her fee and bring him to meet the ferry on the mainland. I would have a new pup in a few hours, but it would mean giving the breeder the last bit of borrowed money I had. I threw caution and sanity to the wind. As the ferry bounced its way back to the island a few hours later, I was on it, holding my guy nestled in my arms under my heavy winter coat. The way I felt told me that somehow I had made the right decision. I was sure at least that my book would be beautiful.

As my inner voice reminded me of the flow, it seemed appropriate to call him River. The name was also a symbol of the trust I had placed in the nurturing, mobility, and sustenance provided by the river of life.

Of course, as I am wont to create nicknames for my Goldens — somehow they demand multiple monikers from us — I often call him River-giver. That he certainly is.

Thinking back to my first thoughts on getting a Golden Retriever, my dog Sonny comes to mind. He was about to be born, having been sired by my friend Joan's perfect dog — Teak. When I directed her to give me one just like him, she admonished me with the information that they did not come from the womb trained. I was informed that I would have to teach and discipline my puppy as one would a child.

Beginning with Sonny, and throughout the rearing of the three boys that followed, I arrogantly and happily dismissed Joan's admonishment. Jake, Tucker, and Breaker, with literally only hours spent in training, won numerous awards for obedience. They were praised constantly for their gentle desire to please me. Enter River. I recall the ominous directive of Julie, the breeder, as she delivered him into my outstretched arms. I was briefed on how this

was an extremely athletic puppy and how I must not let him get away with anything. I had to make sure he knew who was the boss. I cockily boarded the ferry back to Martha's Vineyard with yet another sweet bundle of fur. I humbly admit now that puppy karma is upon me as River and I finish our first year together.

I compare myself to a proud mother who has been blessed with a few perfect children but who decides to have just one more. And then appears Dennis the Menace. It's a recurring theme in my life that just when I think I'm on easy street, the life force jumps up and throws me a new challenge. It mightily proclaims that it's there to renew and invigorate my complacent self. That's my River. He's a major life force jumping up and demanding to be noticed. My love, fond gazes, and saccharine sweet nothings do not satisfy him. He wants most of my energy. I often introduce River as my incorrigible puppy. When questioned as to how I could use such a word to describe him, I answer that his predecessors have occupied no place in my heart that he is not king of. I use this word in jest, aware that his multitudinous wonderful attributes make his incorrigibility actually endearing — or should I say, enduring.

He is River. He is not the gentle brook in Minnesota that begins the far-reaching Mississippi. He is not the rolling, stable Genesee that strings through upstate New York, or the idyllic Hudson that inspired Bierstadt and Moran. He is the mighty Columbia. He is the section of the Maine Allagash best known for whitewater rafting. He is Victoria and Niagara Falls combined. He is the power of propulsion, come to wake and shake me to my core, that bellows, "Here I am, here is your new life. I'm not just a book — fool — I'm a new and different Yellowdog." If *Yellowdog* was a metaphor for the changes in my life, *Yellowpup* — River — is the force of all the elements come to carry me home.

How many times have I turned, for a moment, to answer the phone only to look up and find that River has eaten one arm of a winter coat? How often have I awoken in the night

to the sound of gnawing and loose lips smacking on one of my shoes? Make no mistake. It's not that I think a puppy, even one this cute, should devour my material possessions. It is, however, my reaction that bears notice. I don't get angry. Yes, it is time to crack down and break him of his vile habits, but when he looks up at me begging no remonstrance, I have to oblige him. His obliteration of my belongings has seemed a bit symbolic of my own release from having to know all the answers. I have been so often burdened with worry about what my future holds while clinging tenaciously to my past. River. He roars through my life leaving no sock unturned. He leaps over tall furniture in a single bound. He propels his body from the floor to the top middle of the dining room table with barely a muscle aquiver. He stands then smiling — yes, smiling — with his pearly whites, and twinkling eyes, daring me to chase him. And I do. I grab him by his lunky head, that big head with squinty, grinning eyes set squarely on his strong, wide neck. A friend commented that he looks like a boxer — not the dog, the prizefighter. Her nickname for him is Blockhead. (Of course, he has so many.) We joke that I am a jock mom whose son is the star quarterback winning every game in all good haste so that he can get to the kegger.

I hold that head firmly between my hands. I put my face right up to his. I begin to chastise him. He looks at me and laughs — yes, laughs — and I say, "River, River, you are really something, boy!" And I laugh back, managing to get in that he should not repeat the offense. When he is not performing such antics, I worry but know that, of course, it's only because he's growing, maturing as I am myself. But oh, how I love him. How I love that fearless, laughing life force that pants in my face and makes me want to embarrass myself. That incredible spirit roaring to me to take life by its wind and answer with directness that I fear not. I want to be like River. No, I have not developed a taste for wool, cotton, or Gore-Tex, but I am developing a hunger for movement. For being inspired by a notion, for answering yes and jumping

whole-dog (if you will) into the moment. River has not been my perfect dog. But he has been the perfect dog to shake me out of my own need for perfection. I love his challenge. To always be right and of too elegant mind has been a burdensome task. To be frivolous, daring, and just plain fun is the challenge. River is fun. River is safe but he is fun. River is sane but he is silly. River is my new ride, and what a thrilling ride it is. River is an eater of life. I wish to be more like him and be an eater of life. I thank the universe for this dynamic spark plug, for this catalyst. The beauty of a catalyst is that it can come in and provoke the necessary changes while remaining itself unchanged. River is still River. He is my flow.

Yellowpup

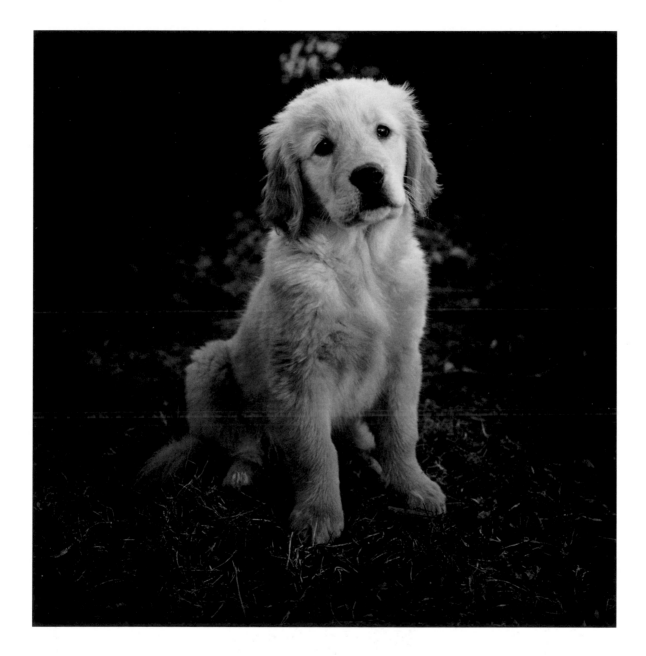

Breaker

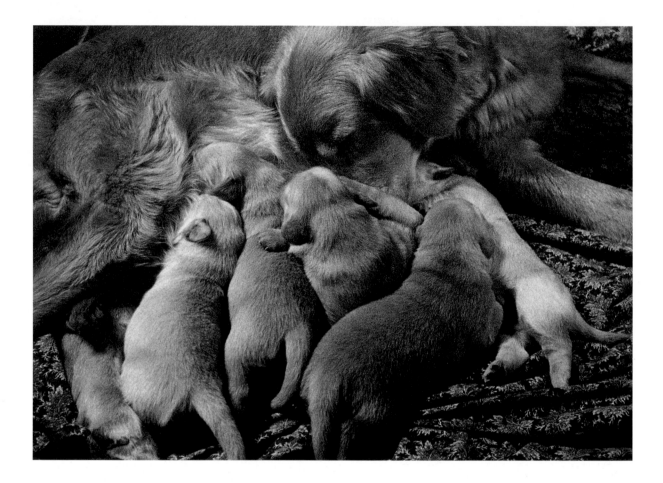

The Mother Lode

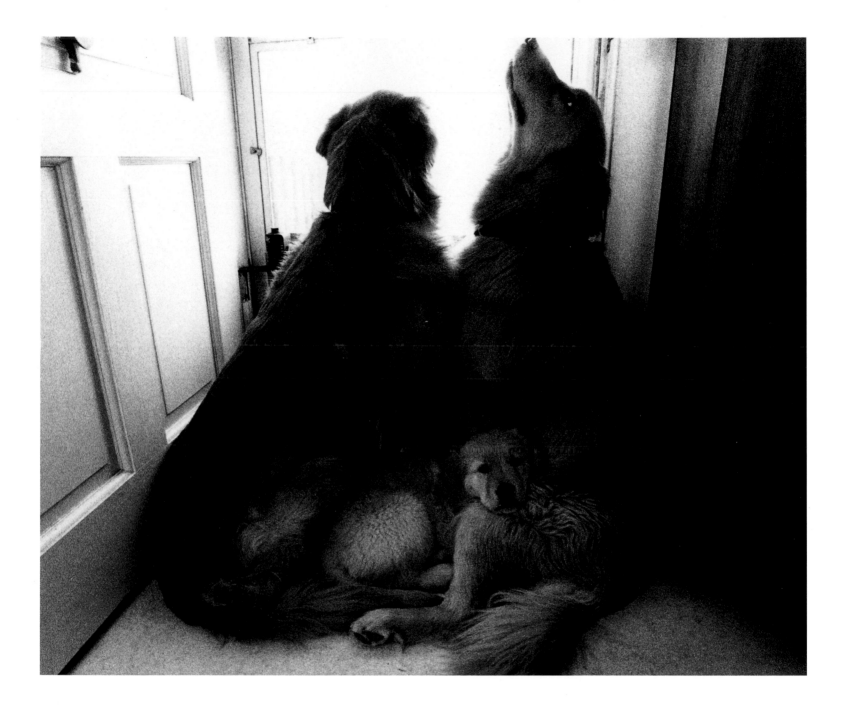

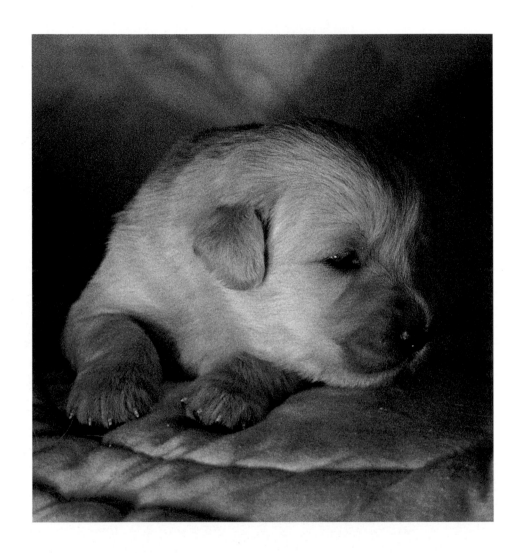

Babyface

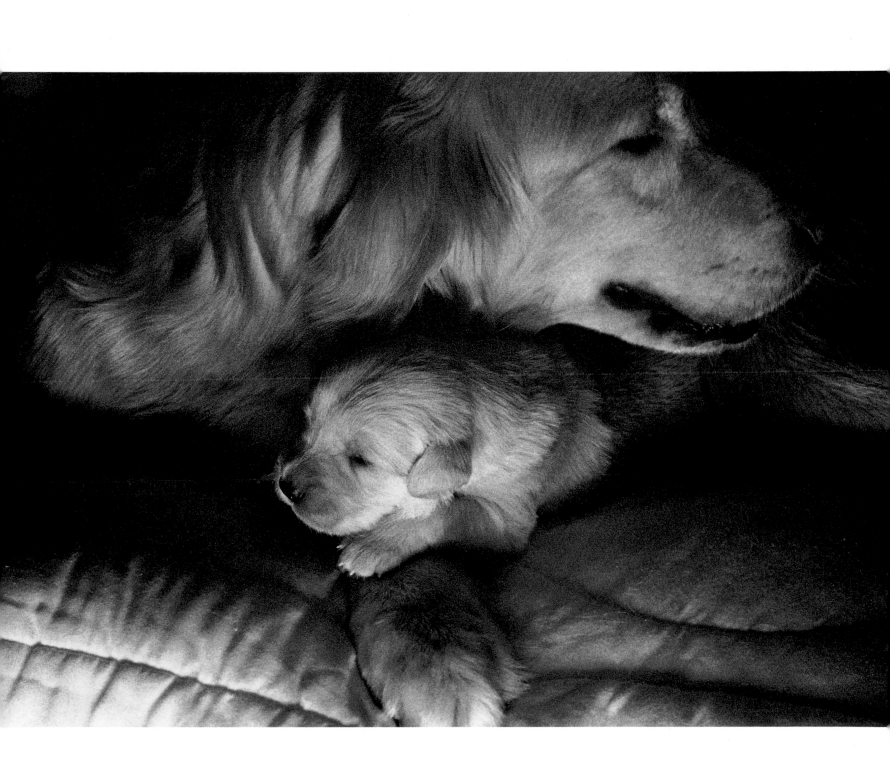

Mother Love

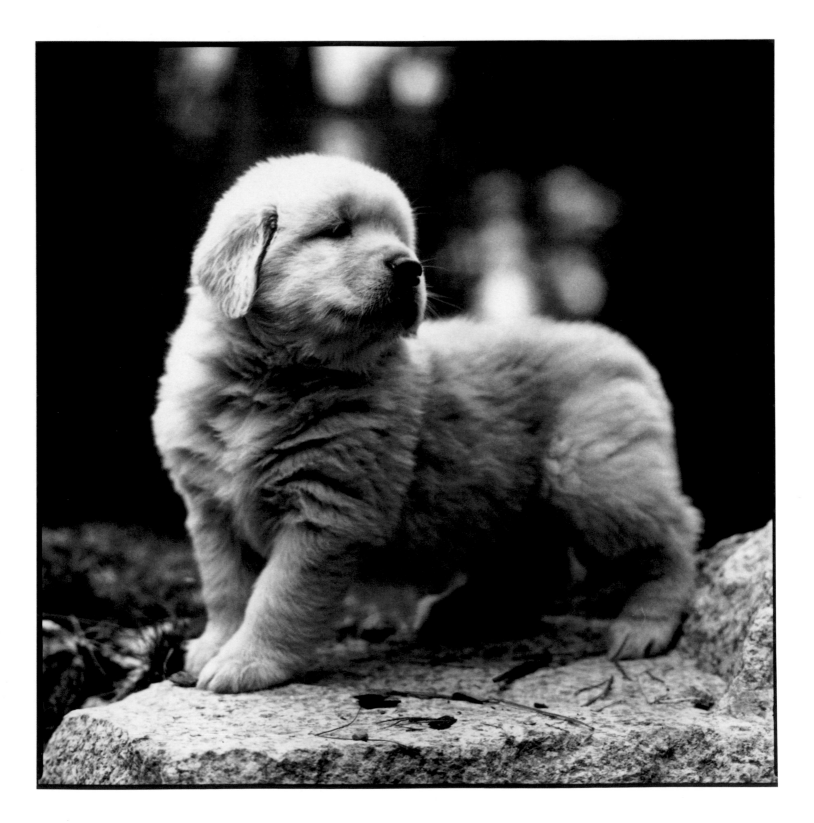

Beauty

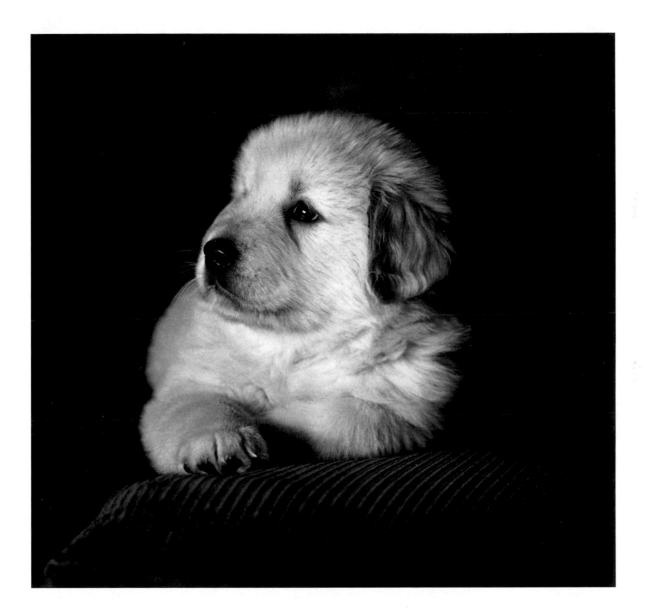

River "Churchill"

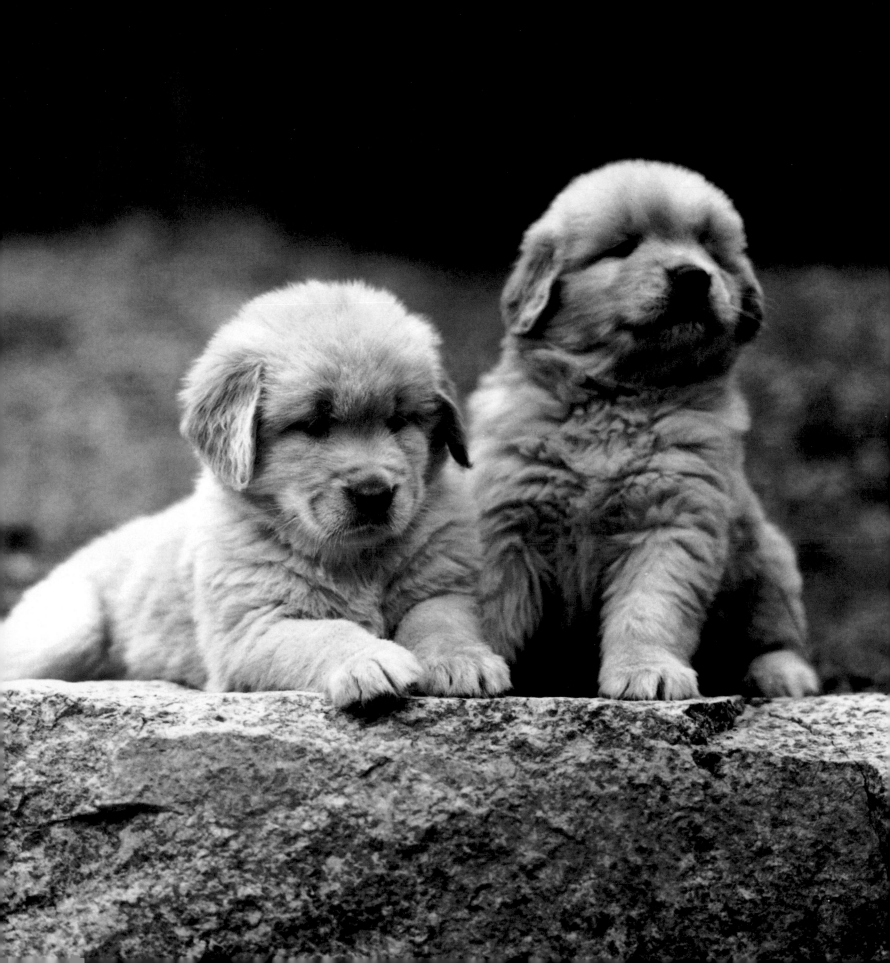

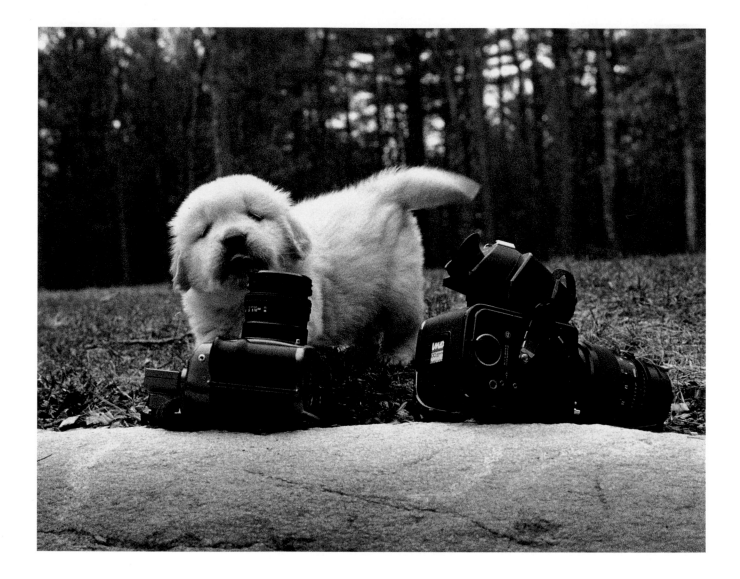

Something to Eat?

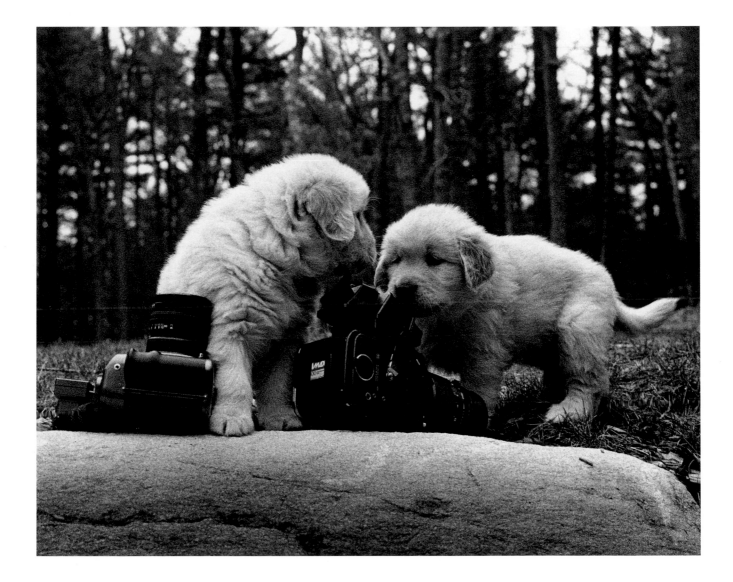

Want to Share?

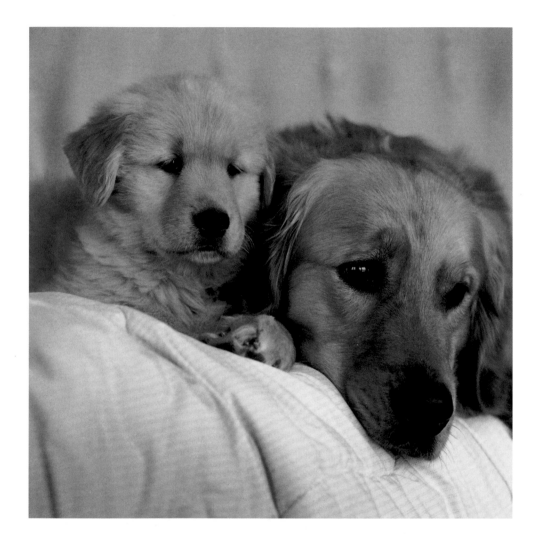

Breaker's New Baby

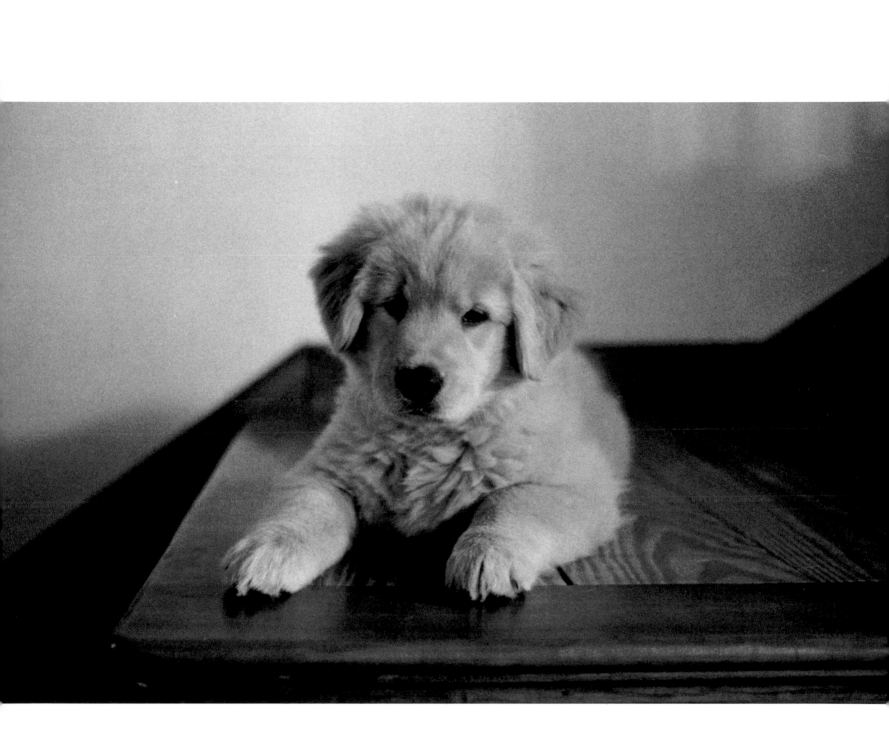

Puzzled Pup

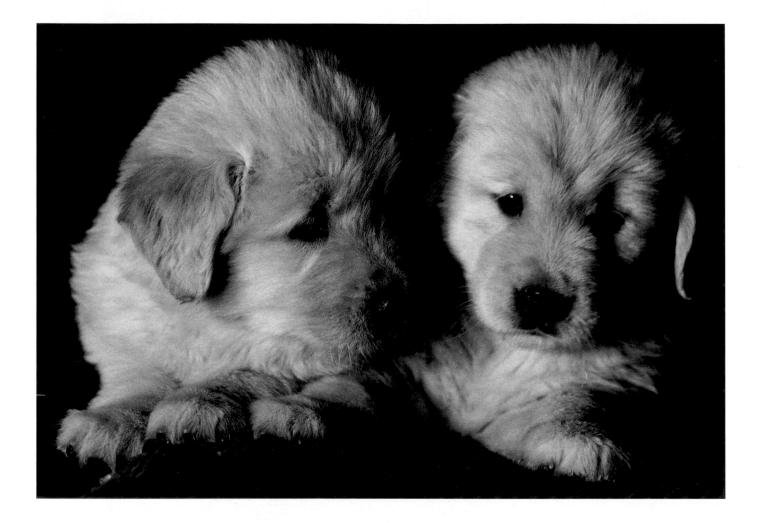

Now, Dear . . .

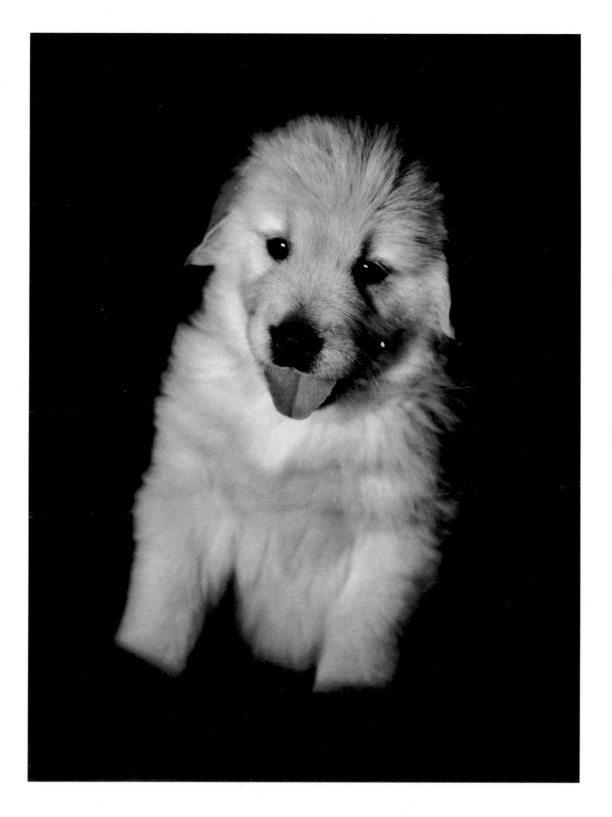

River . . . Eater of Life

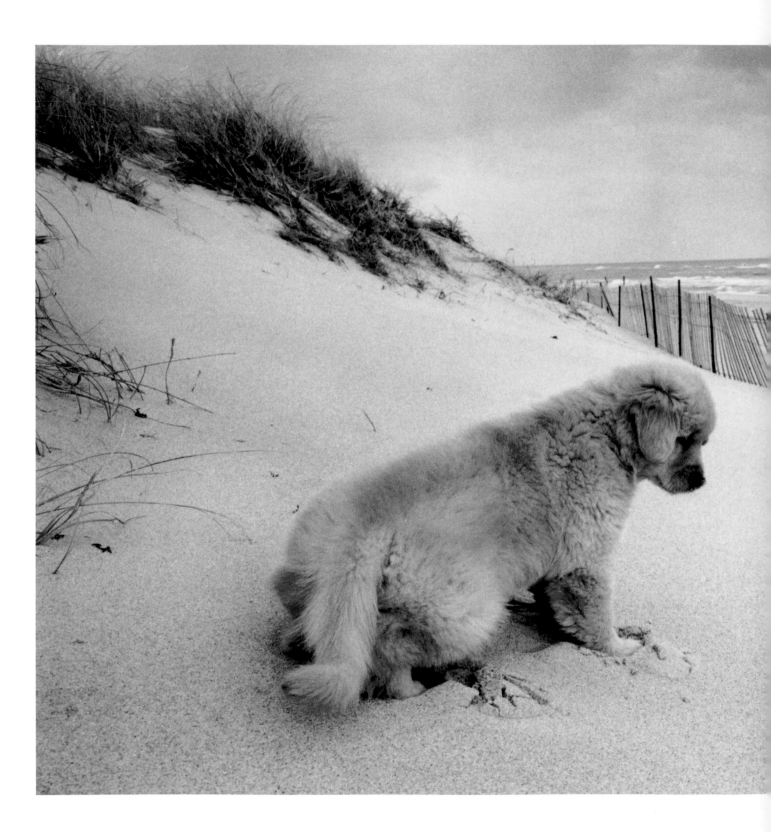

The Tenuous New Horizon

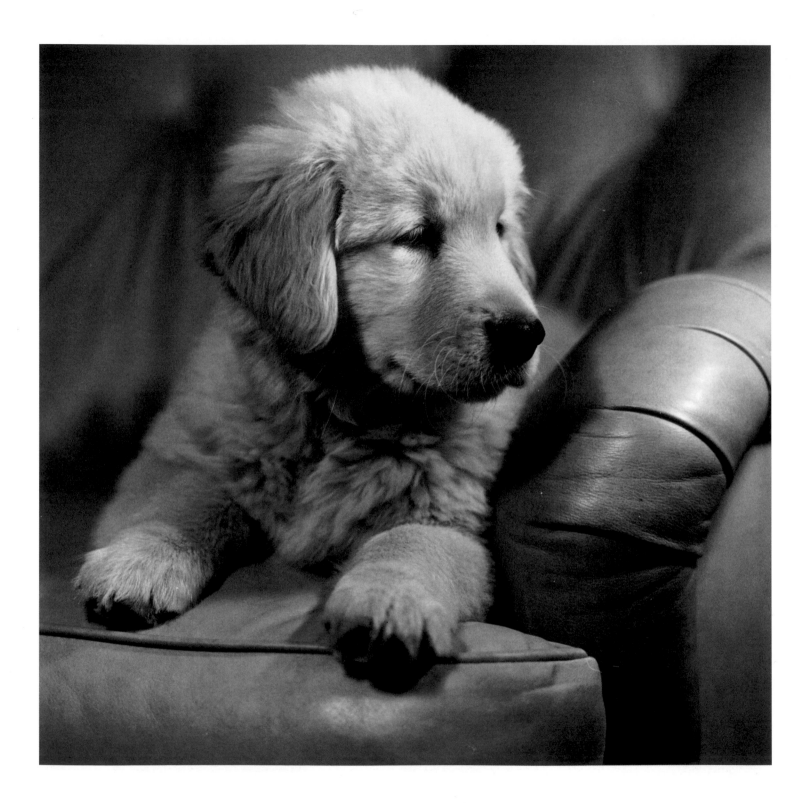

Club Pup

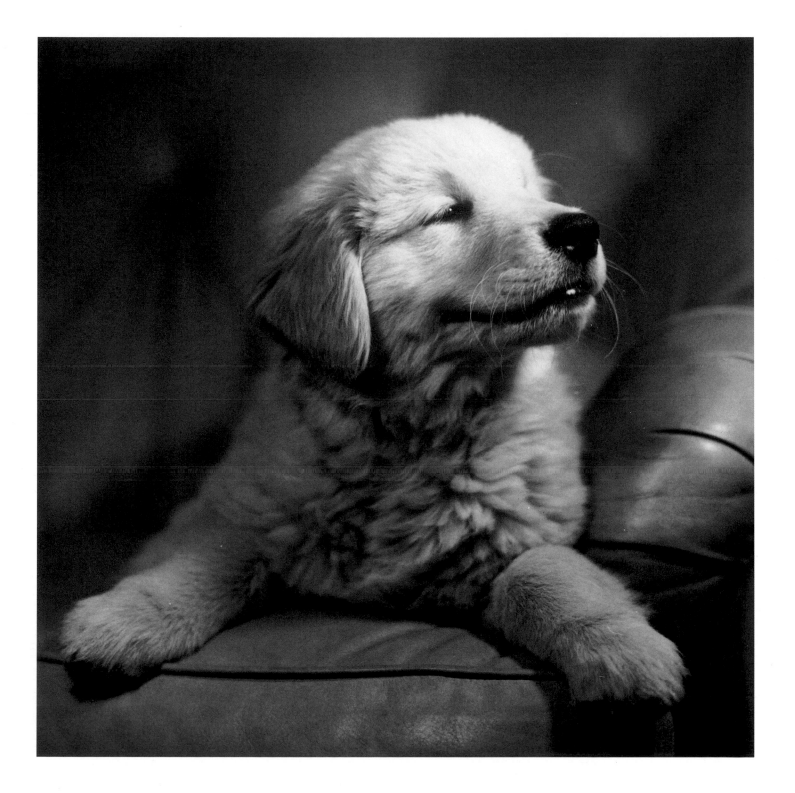

Garçon?

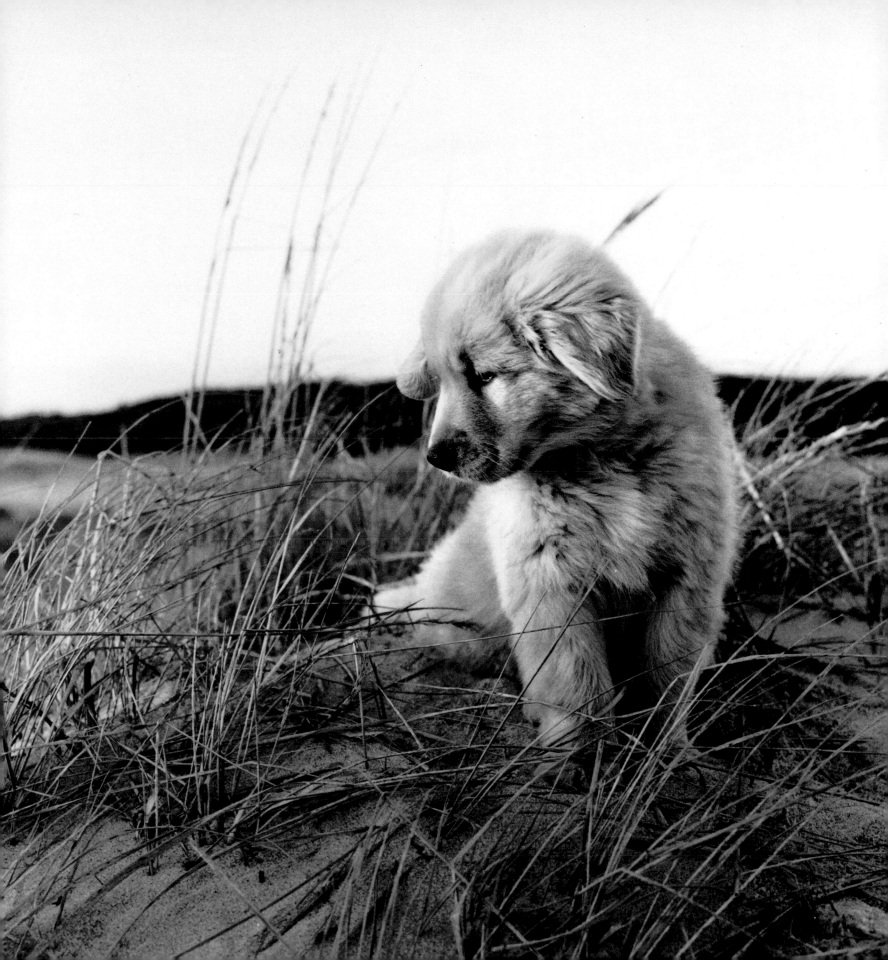

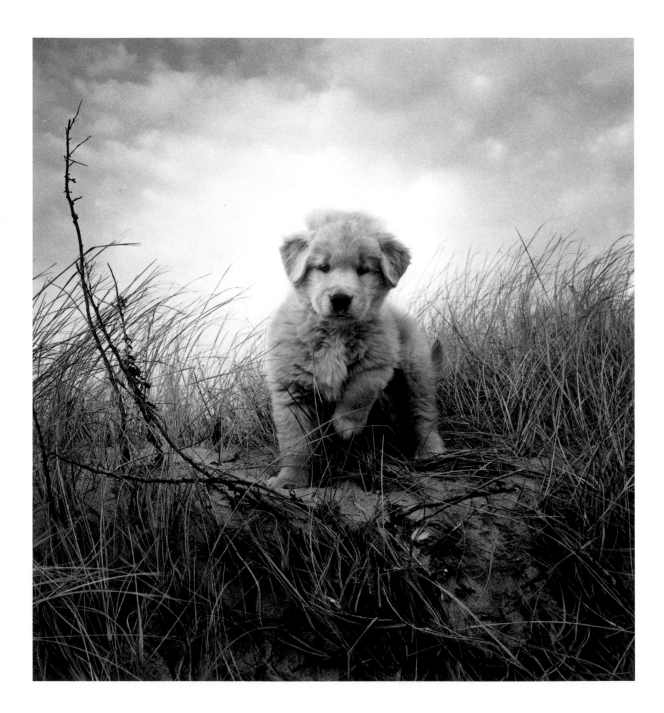

The Wild One

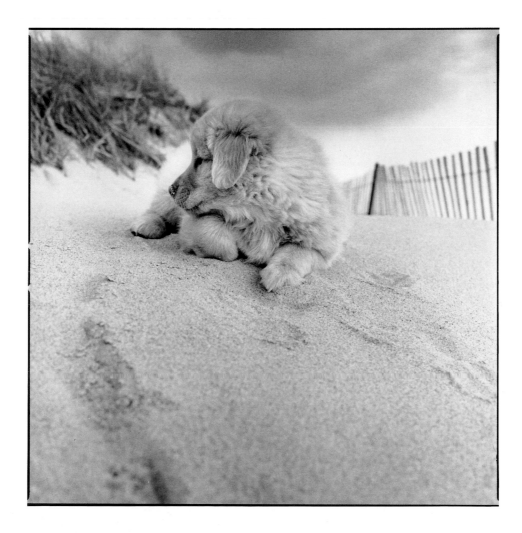

Beach Boy

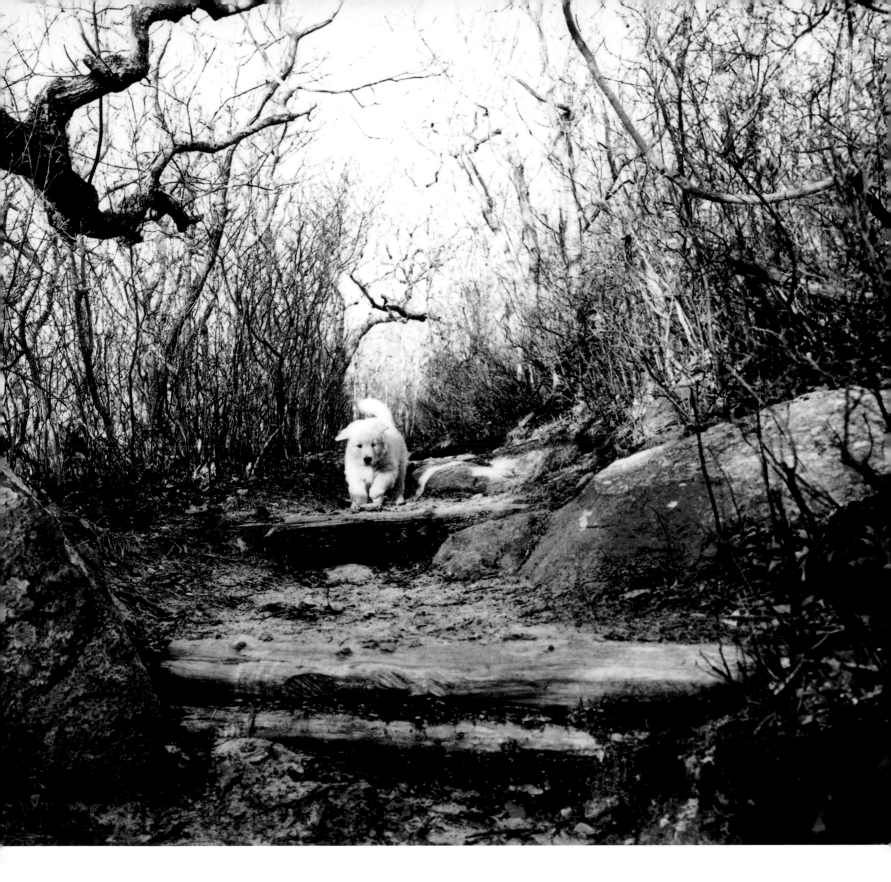

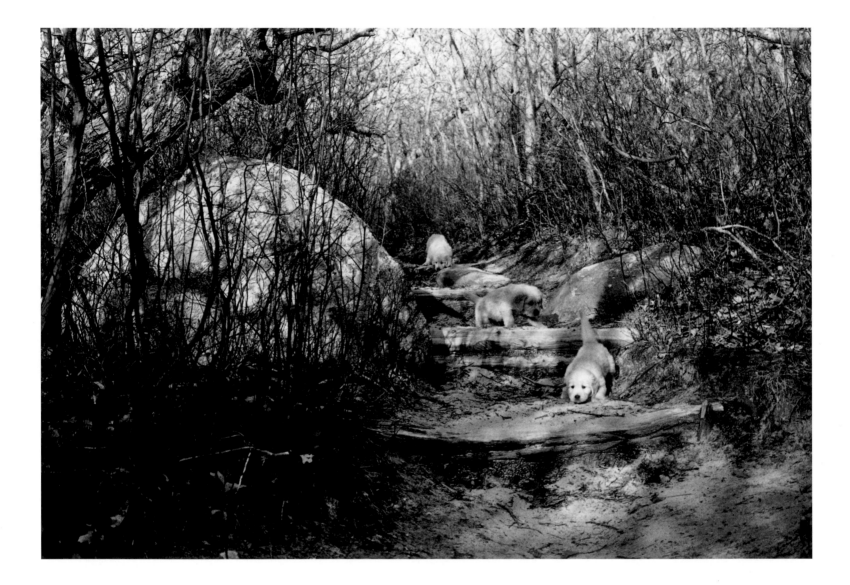

The Puppy Trail

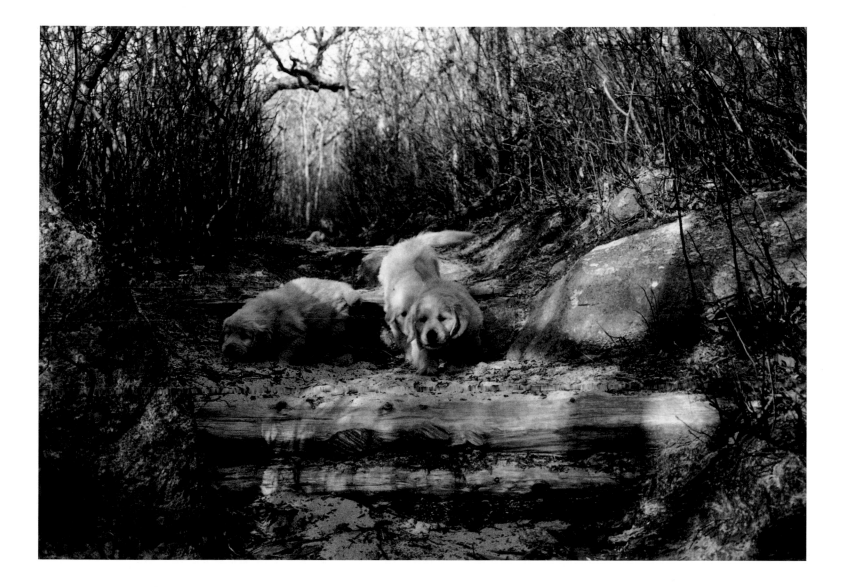

Puppy Trail II

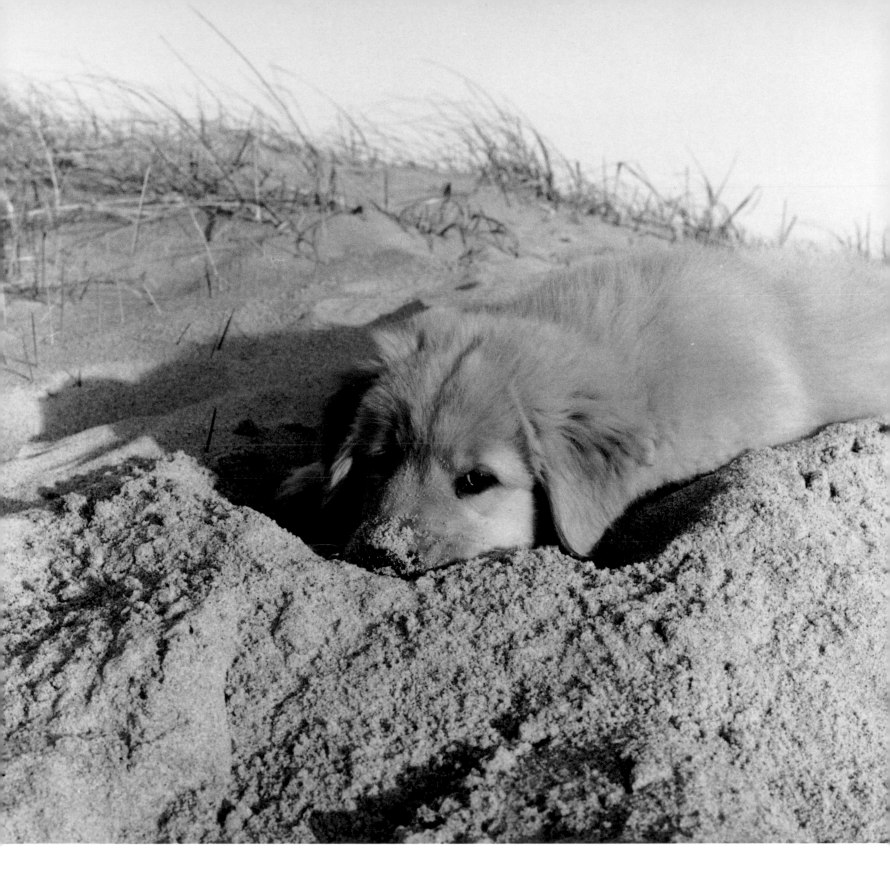

Dune Digger

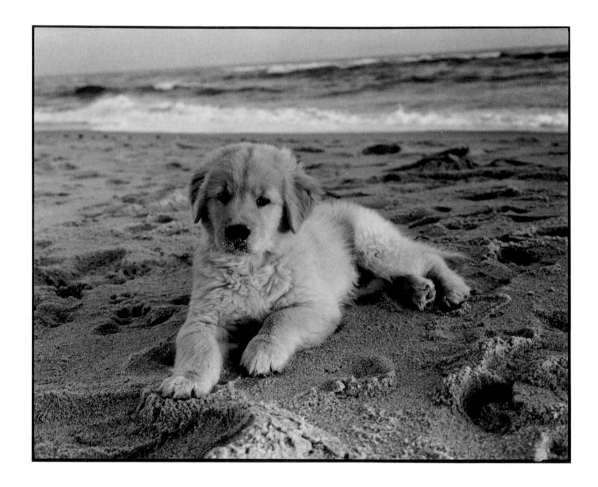

Beach Lips

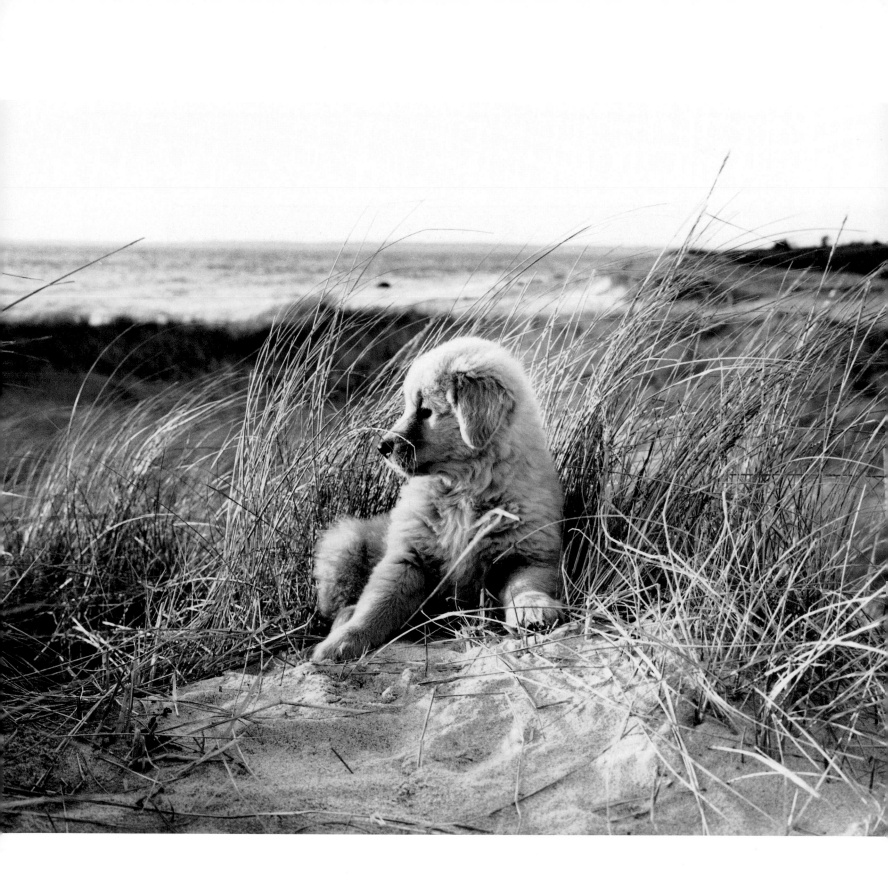

River's World

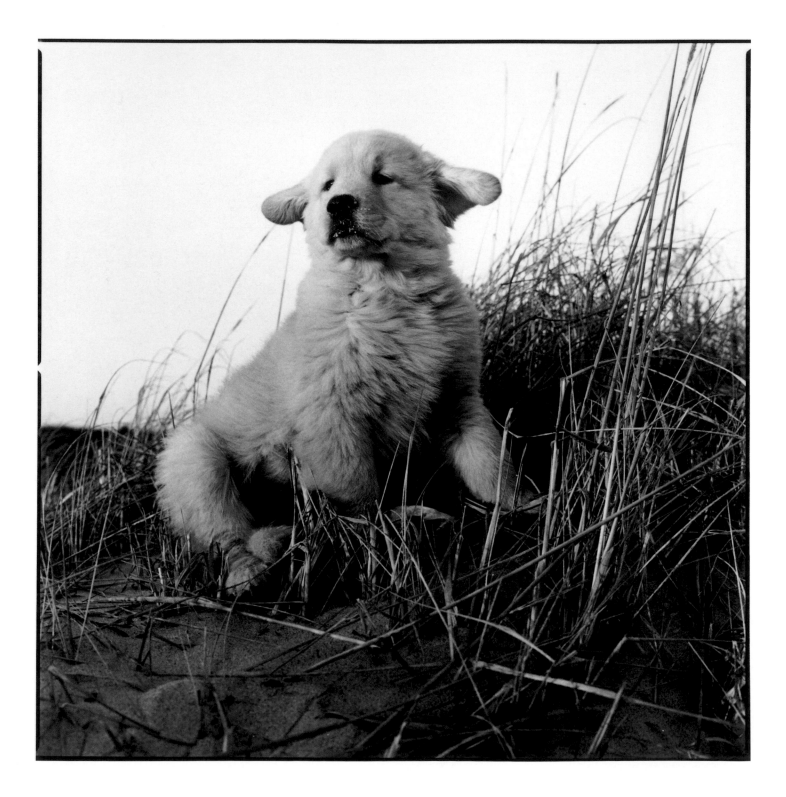

Angel Ears

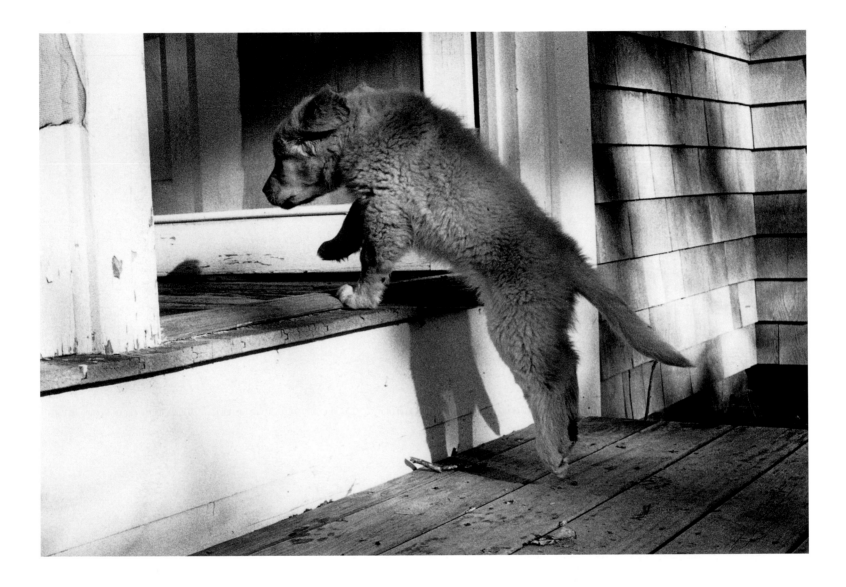

Breaker's Will

49

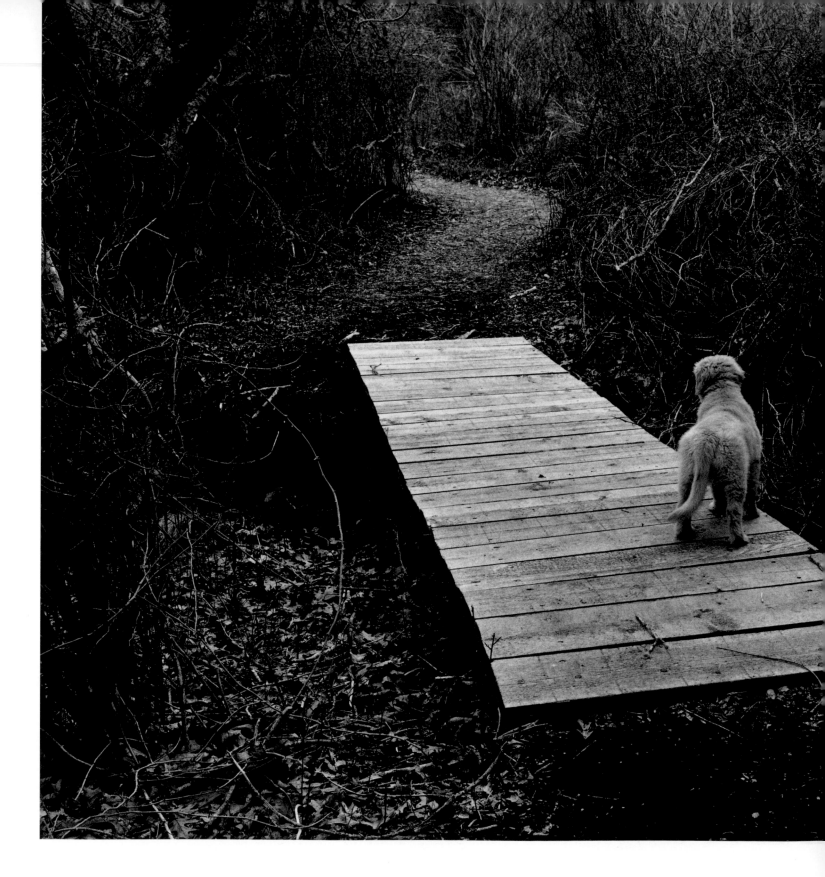

The Bridge to the Long and Winding World

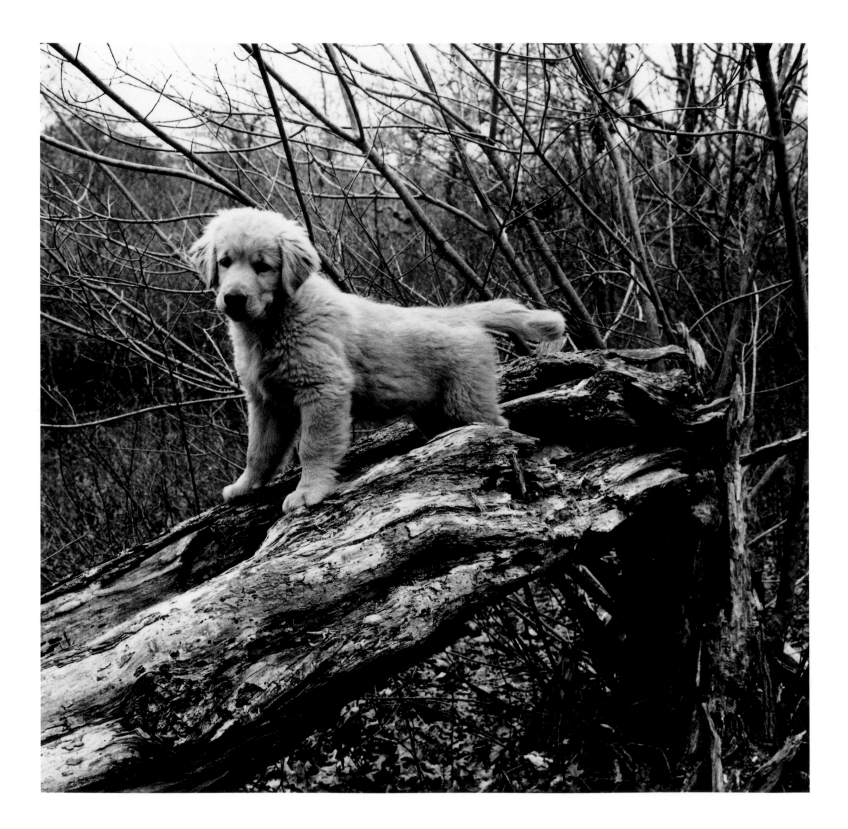

Stump Pup

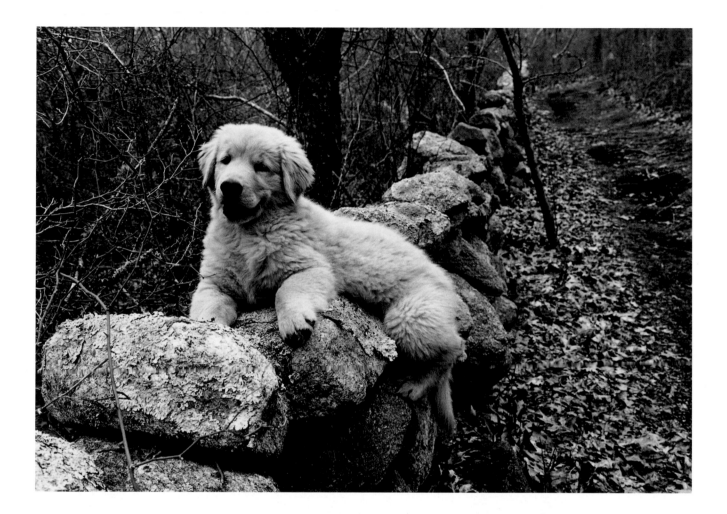

Rock Climbing

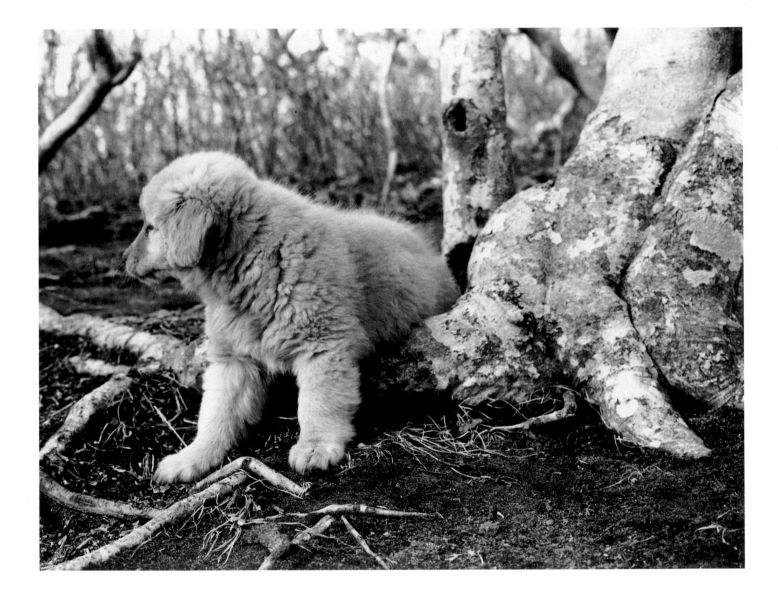

Stuck Pup

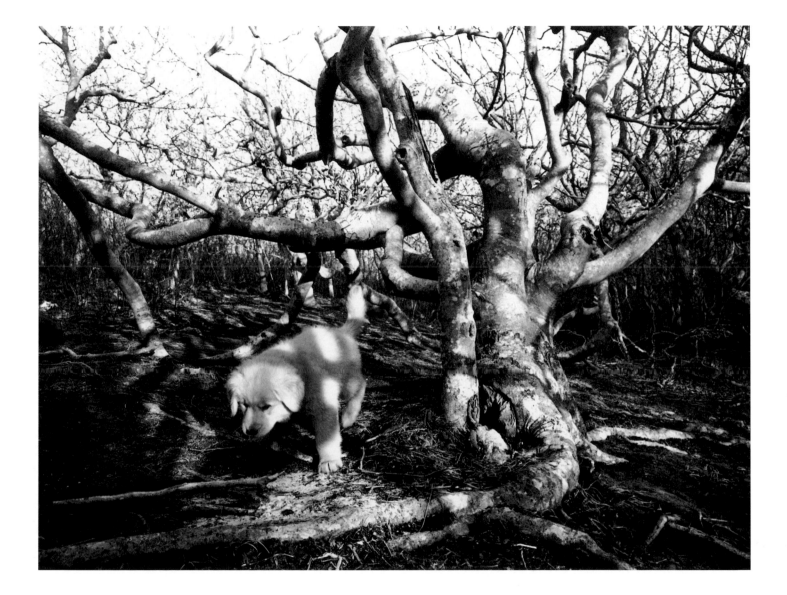

The Maze

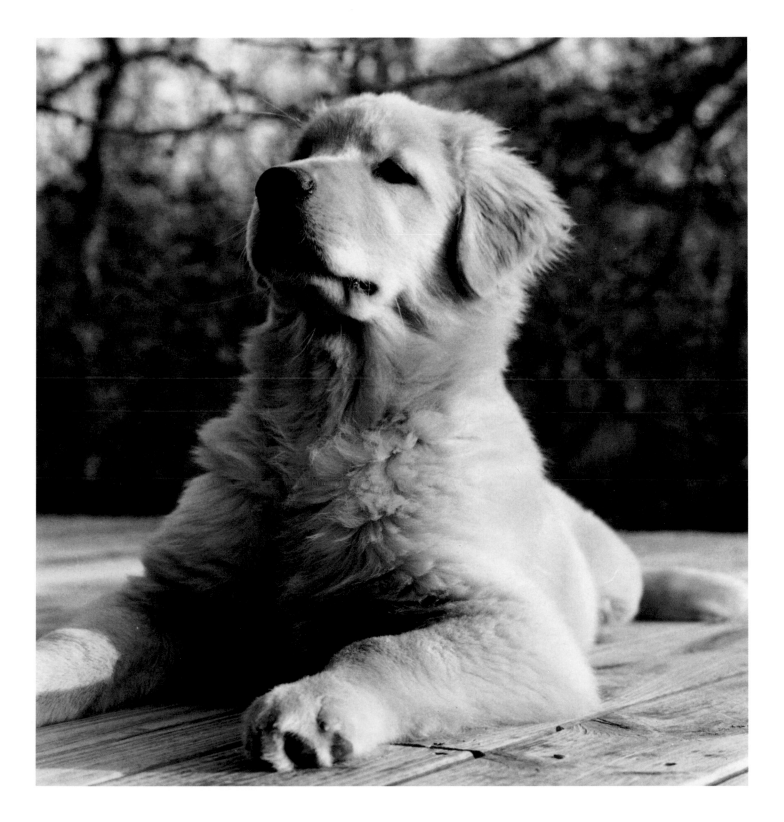

Nobility

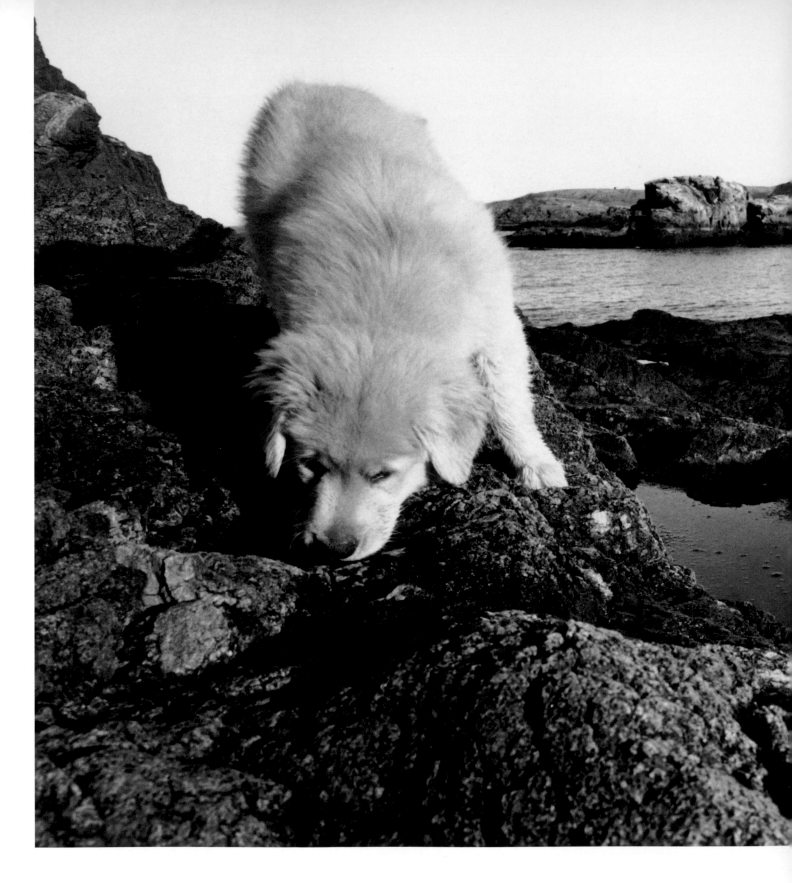

Curiosity

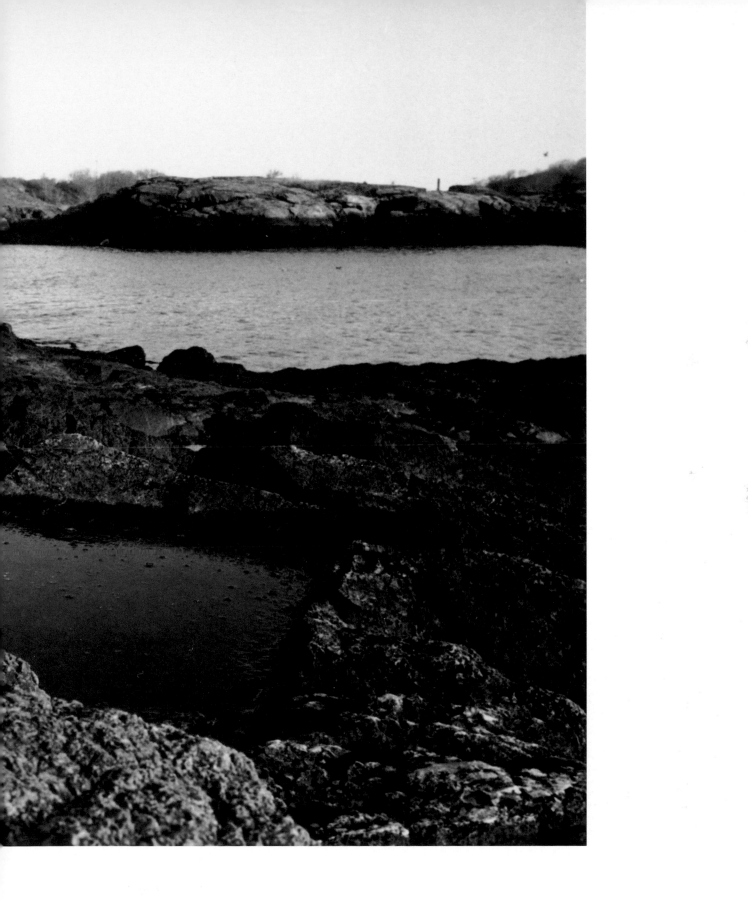

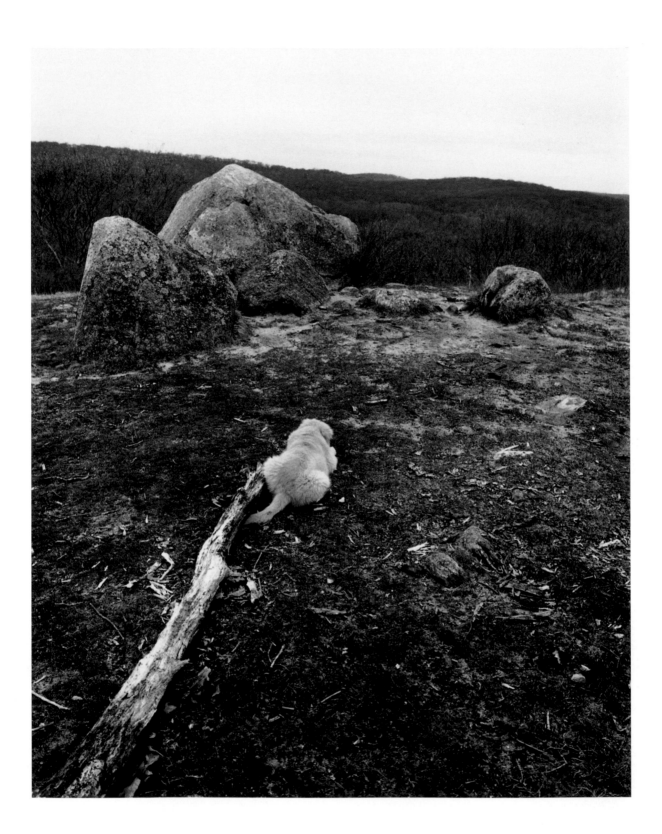

Chew Stick

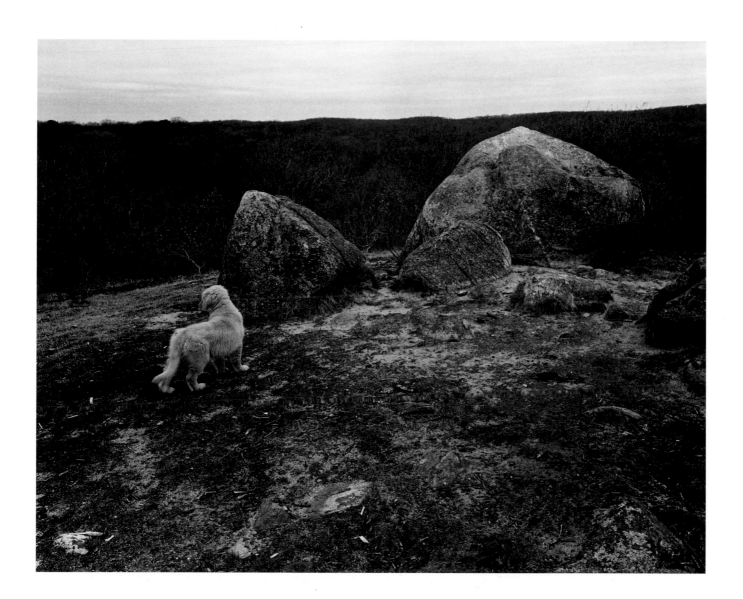

Waskosims Hill

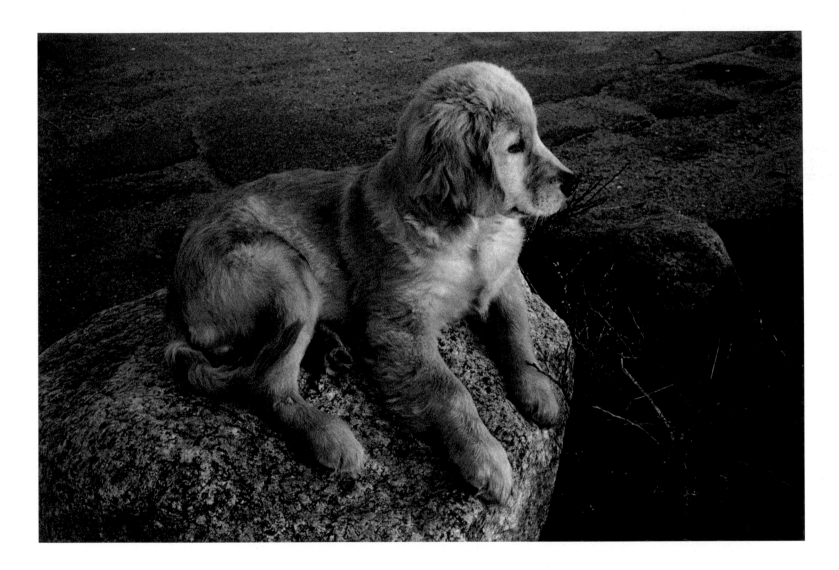

The Meditation

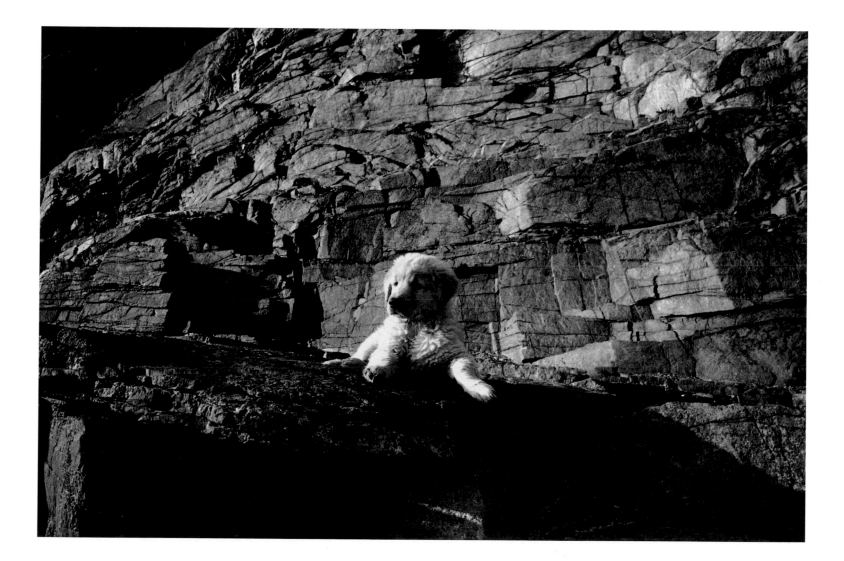

Forty Steps in Nahant

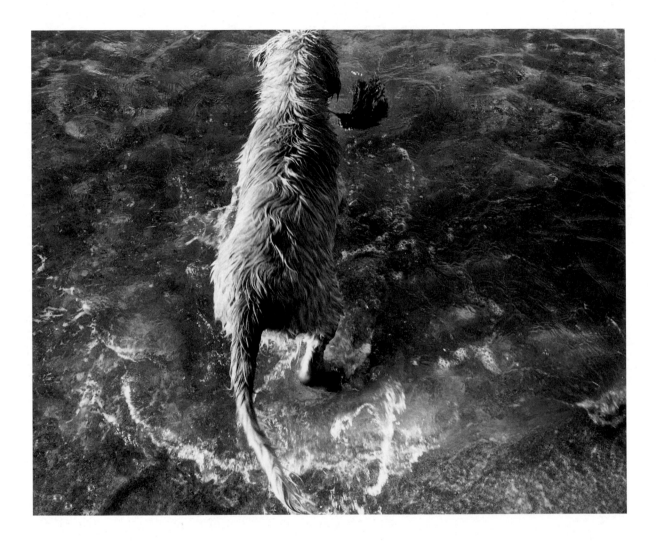

The River Meets the Sea

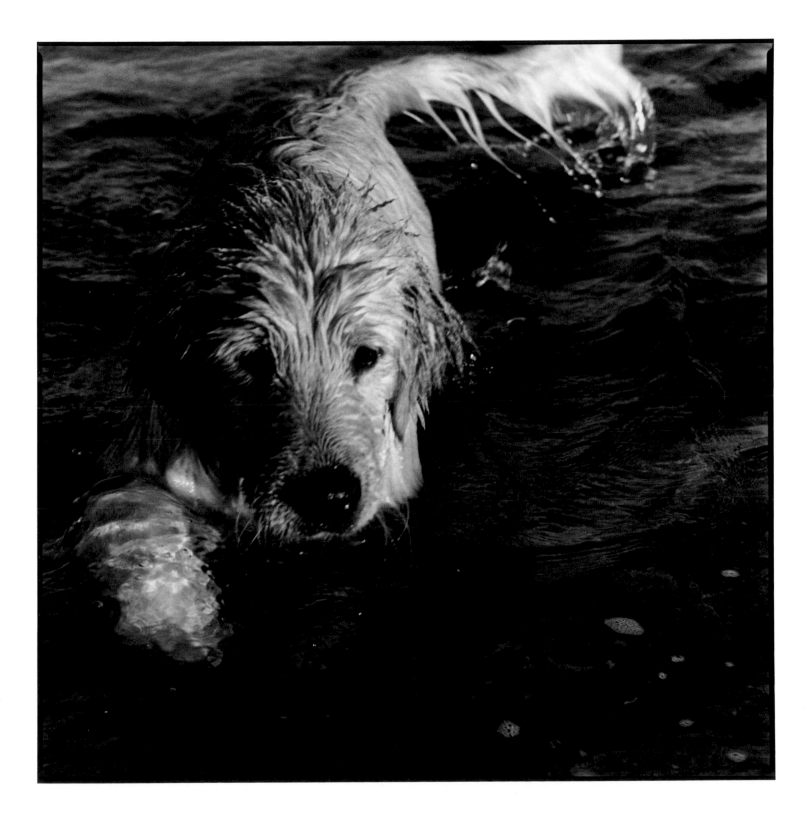

Waterlove II

Dune Pup

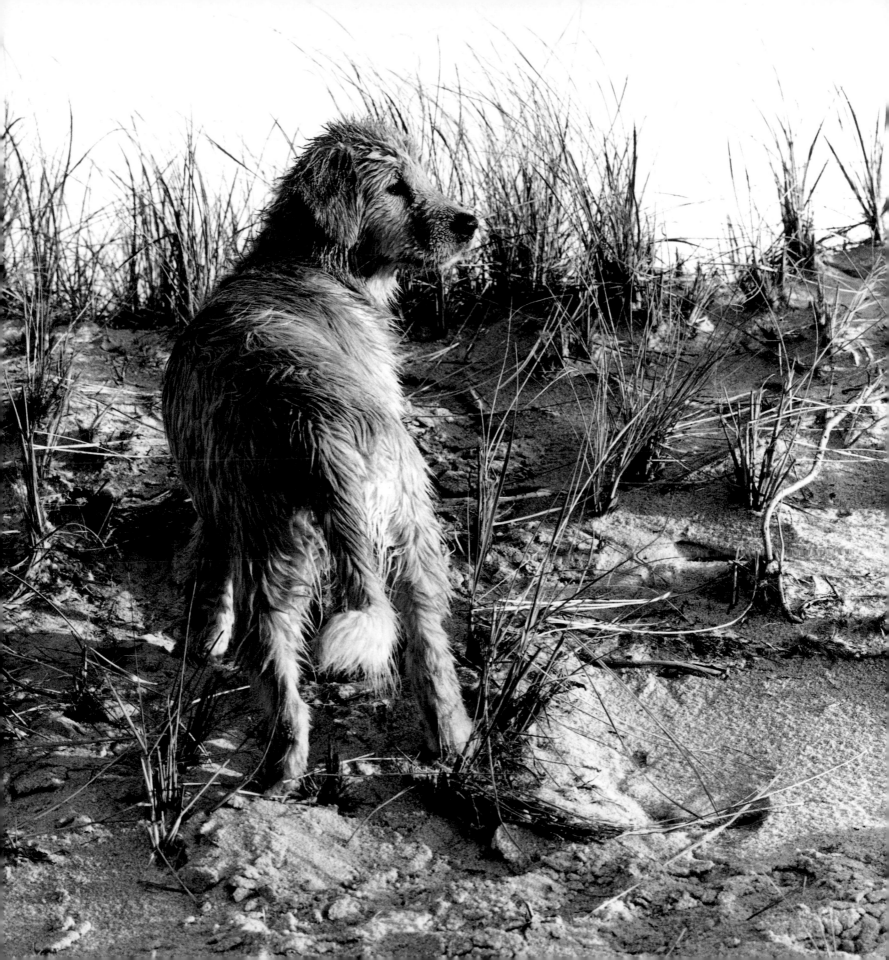

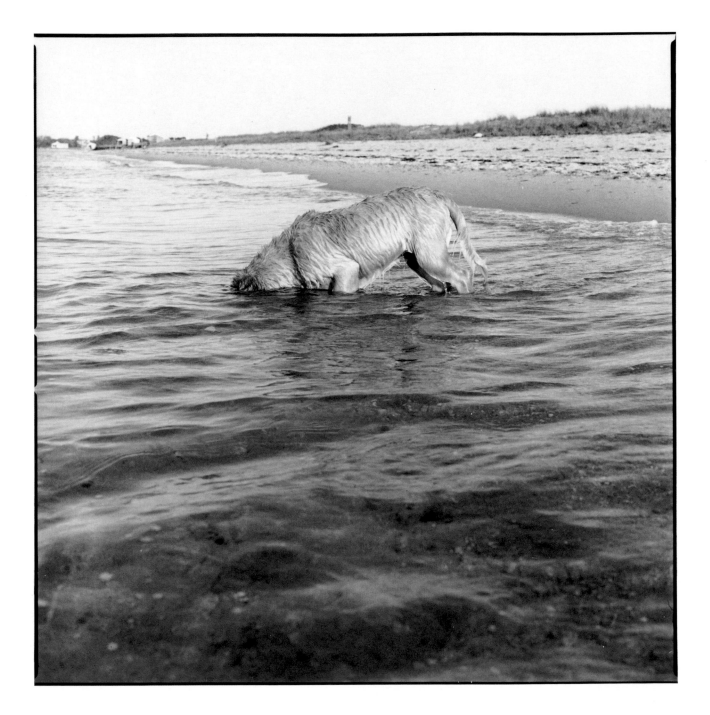

Sea Dog

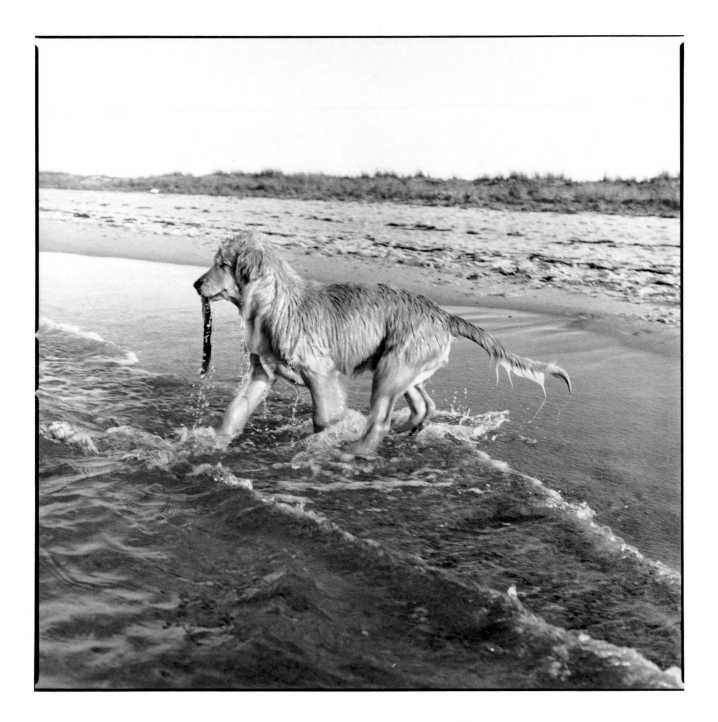

River's Catch

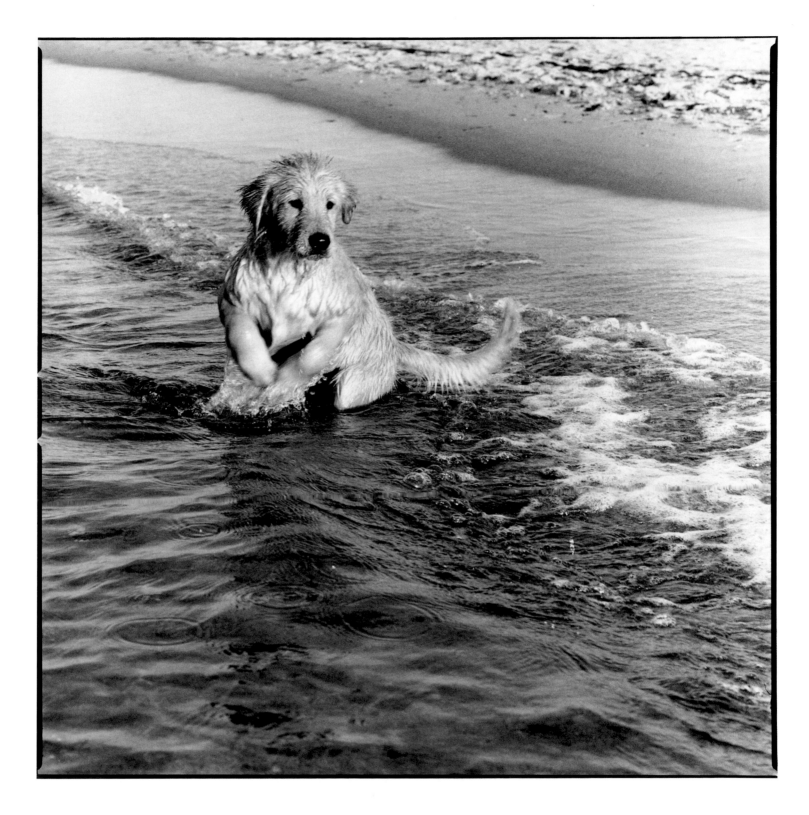

River's First Swim

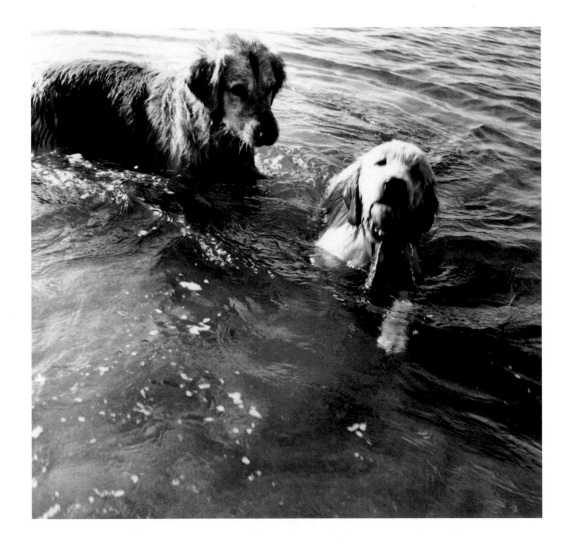

Tucker's Triumph

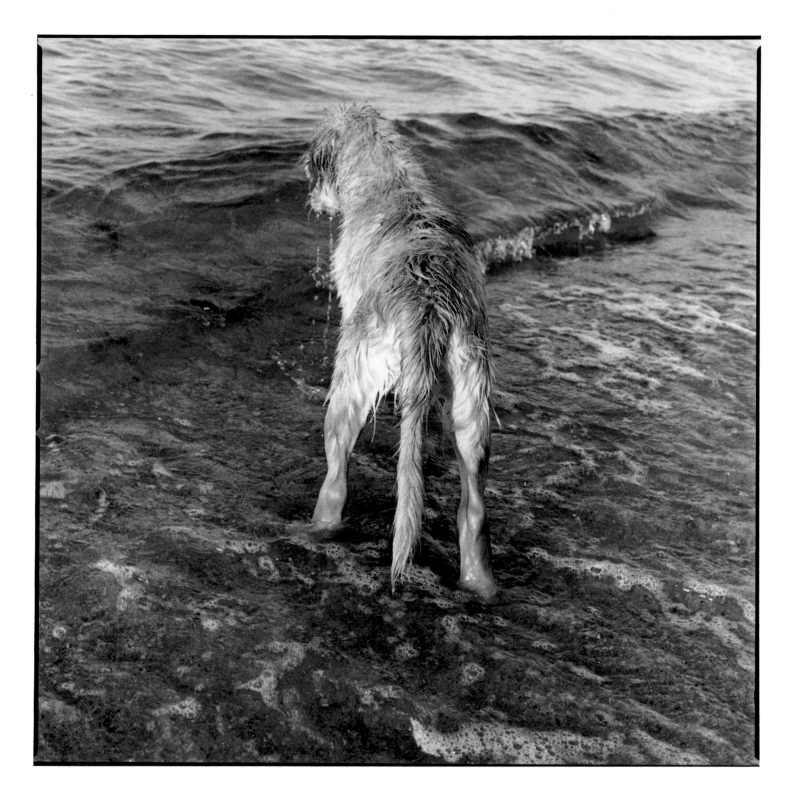

Surf Fishing

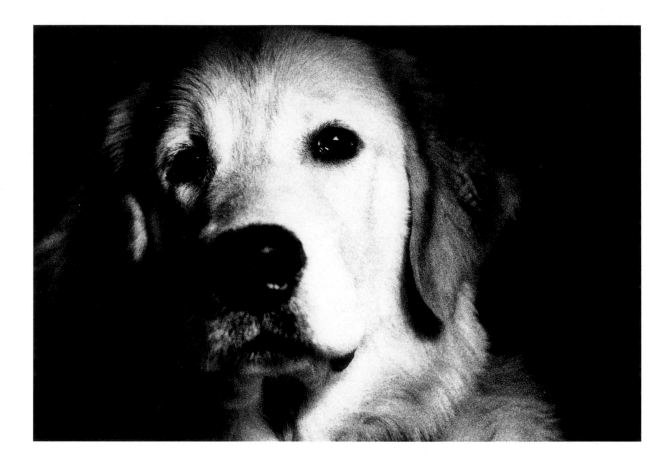

Lake's Soul

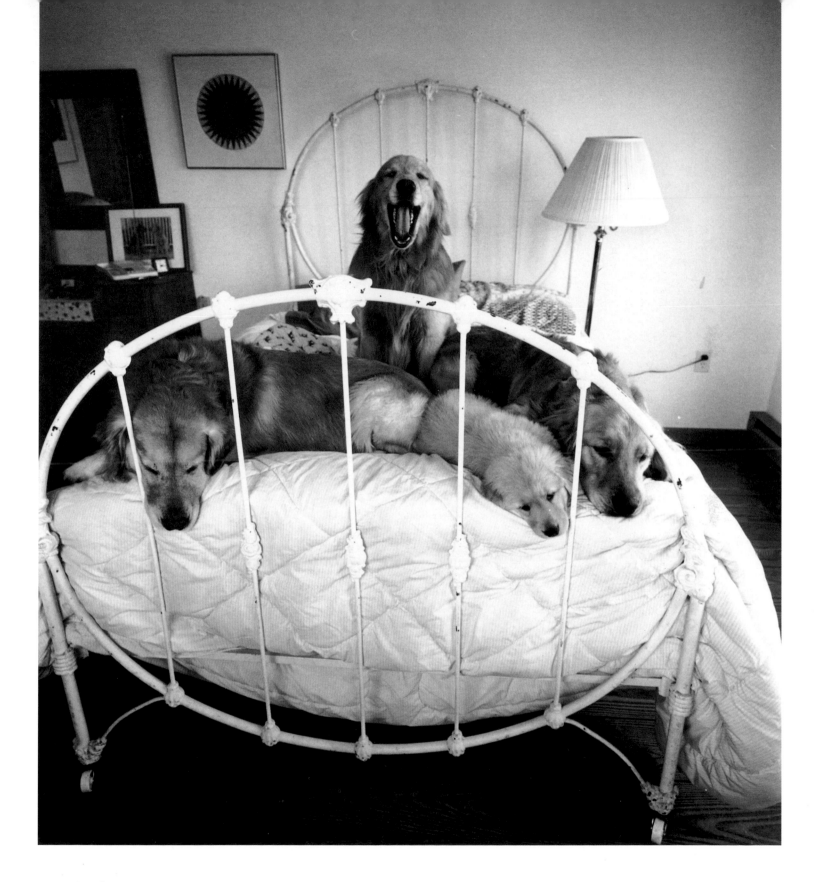

Sunday Morning

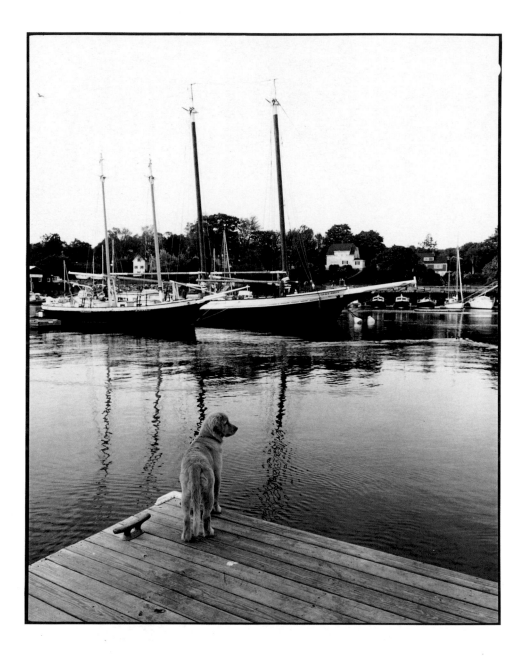

Harbor Patrol

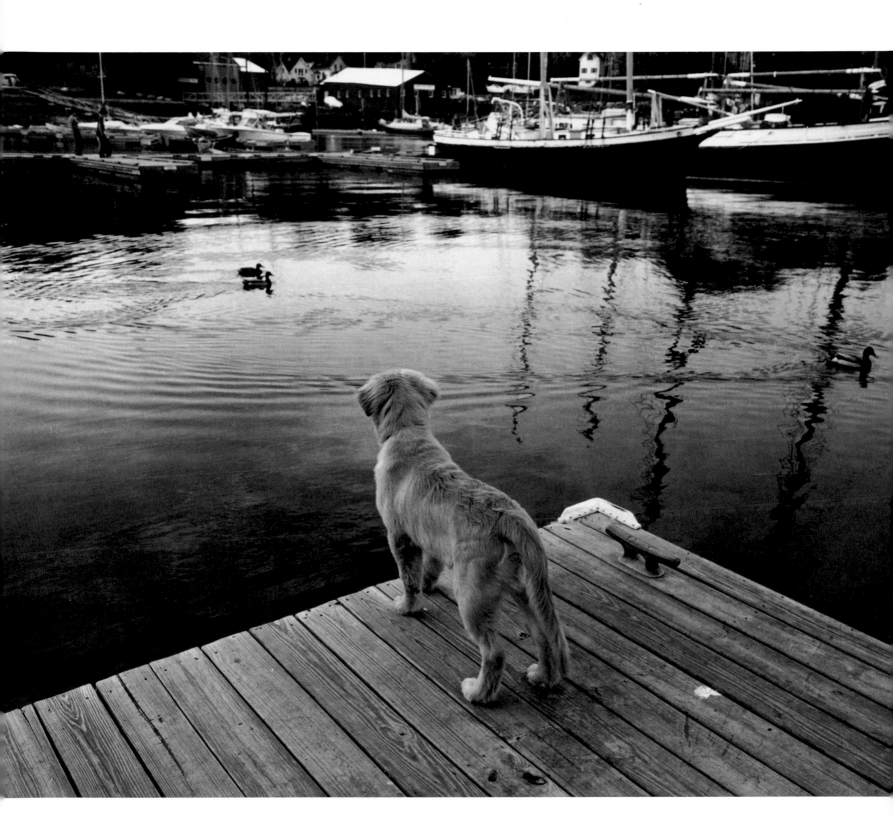

Duck Watch

Acknowledgments

◆

I WOULD LIKE TO THANK Steve and Amy Scott for their generous support of me, my dogs, and Yellowdog Gallery. From the first they have shared my vision and promoted my purpose, and . . . they have three Golden Retrievers.

With deep appreciation to my publisher at Bulfinch Press/Little, Brown, Carol Leslie, and to my editor, Janet Bush. I revere Janet. To me she is synonymous with fine-art black-and-white photographic publishing. She is also very warm and understanding of my foibles and tardiness. Special thanks to Janet's assistant, Tiffany Reed, who, through humor and understanding, has the ability to extrapolate a great story. Thanks also to production associate Melissa Langen and designer Jeanne Abboud for the beautiful design of my books.

Thank you to Julie MacKennon of Nautilus Golden Retrievers in Plymouth, Massachusetts. Three of my four boys were bred by her. They all look a bit different but have the same enormous capacity for love and humor. She bred my Yellowpup, River, thus opening for me a whole new dimension of joy.

Thank you with all my heart to Regina Ryan, my agent and friend. She is very patient with an author's frustrations, and so diplomatic. She truly cares about what happens to me. I know we will accomplish much through the years.

I am so grateful to my friend and benefactor Ellen Gormley and her son Nick Gormley from Marblehead, Massachusetts. They share my vision for the vast scope of *Yellowdog* and together they sprung me from my solitude on Martha's Vineyard.

Thank you to Barbara Ivacek, my friend and astrologer in Prescott, Arizona; Sandy Wand, who is a friend and visionary healer from Ashland, Oregon; and Sandra Swales, a friend and a world-renowned Tarot reader from Carver, Massachusetts.

I don't know what I would have done all these years were it not for my friend and attorney Eli Mavros, of Lynn, Massachusetts. He not only has helped me, always at a moment's notice, with legal affairs, but makes the world's best chicken soup. He and his wife, my friend Elaine, have always been warmly hospitable, and I love them as family.

All my love to my dearest friends Peter and Lilian Johnson of Chilmark, Massachusetts. Their constant warmth and spiritual support buoys me in times of sadness and confusion.

Thank you to Barbara and David Brown of Tempo Golden Retrievers in Dallas, Texas. They bred my dog Breaker who also appears in *Yellowpup*. I adore him for the very, very special sensitive creature that he is.

My enormous gratitude to Attorney Janet Bostwick of Sherin & Lodgen in Boston. She helps me with my literary contracts and is always patient with my many questions.

Thanks to Pam Higgins of Sandwich, Massachusetts, for bringing several of her puppies over to Martha's Vineyard to be photographed. She is kind and breeds beautiful Golden Retrievers.

A very special thank you to Rob Hicklin of the Charleston Renaissance Gallery in Charleston, South Carolina, for taking me into his beautiful building with my four wonderful dogs.

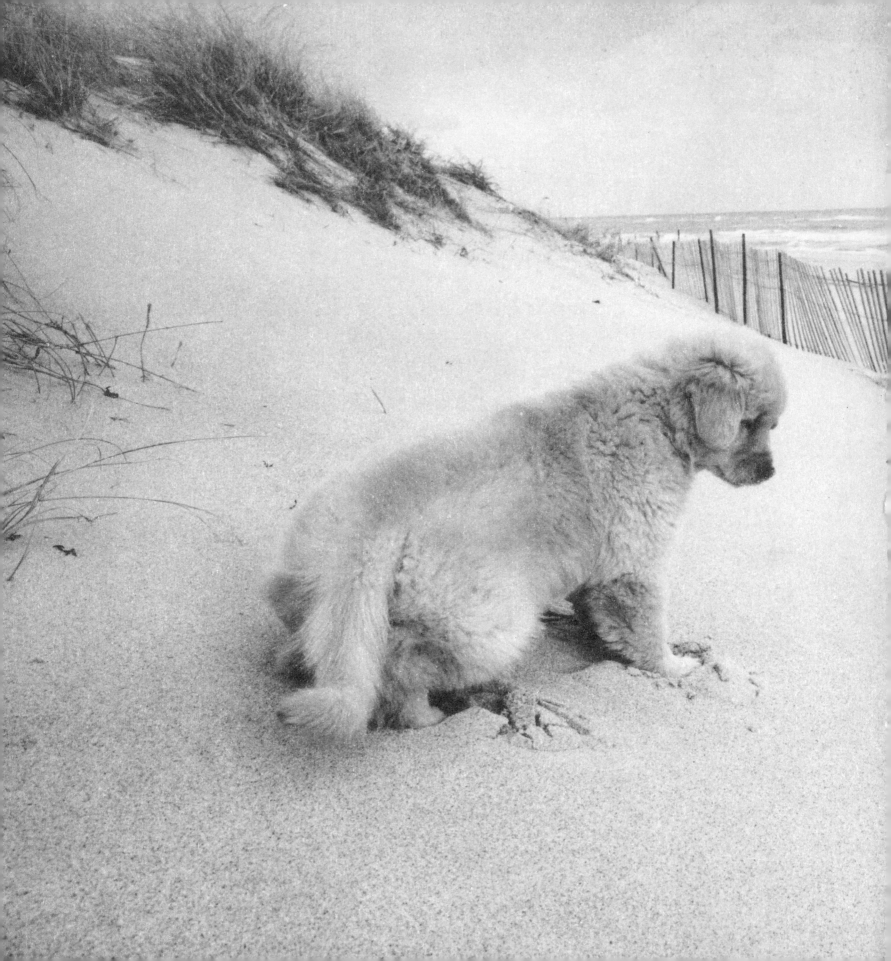